ON FIRM GROUND

ON FIRM GROUND

Larry Kanfer

PHOTOGRAPHS BY LARRY KANFER

UNIVERSITY OF ILLINOIS PRESS

URBANA AND CHICAGO

Library of Congress Cataloging-in-Publication Data

Kanfer, Larry, 1956–

On firm ground : photographs / by Larry Kanfer.

p. cm.

ISBN 0-252-02640-3 (cloth : alk. paper)

1. Landscape photography—Middle West. I. Title.

TR660.5.K3396 2001

779'.3678'092—dc21 00-010833

For Alaina and Anna,

who remind me daily to look beyond the puffs of wind

to that which is enduring.

PREFACE

I often wonder what outsiders think when they find themselves in the heart of the country, far away from ephemera, trends, and rapid changes, far away from the so-called cultural and economic centers of the United States, in a place where a particular plot of earth has been coaxed into producing its bountiful gifts for generations. What do outsiders say about what has been built by human hands on this firm ground?

I was once an outsider myself, transplanted to the Midwest from a coastal city. I expected to find a landscape devoid of change, of beauty, of life, but it was here that I first discovered the subtle splendor of a flat surface stretching all the way out to meet the horizon. Over the years I have discovered many layers of beauty in the midwestern landscape, beginning at the surface with the geometric patterns of field furrows juxtaposed with the swirls of natural formations (*Diamonds in the Rough*), or the detailed foreground punctuating an open sky with delicate white flowers (*Queen Anne's Festival*).

I have also observed the spellbinding power of the seasons. Here, winter settles, embossing the landscape while its inhabitants seem to hibernate until, slowly at first, the stillness lifts (*January Thaw*). Some color starts to peek through, and the snow cover soon gives way to a glorious richness (*Groundbreaking*). This begins a three-month period of re-emergence and renewal of acquaintances (*Trillium*). Energy abounds—and with it comes the heat. What was light and dry becomes heavy with humidity (*Philo Summer*), and the horizon line gradually disappears behind a wall of corn (*Standing Ovation*). Before long, the cornstalks turn brown as autumn gains momentum. Then, after a riot of color changes (*Fall Recital*), the horizon line becomes visible once more as the earth is shaved in preparation for the winter winds (*Loyal Citizens*). And we start again.

The most impressive thing to me about the Midwest is how our lives are intertwined with the seasonal cycles. While we appreciate the coolness of fall and the greening of spring, we can-

not do so passively. The whims of nature demand our attention and guide our actions. A thin sliver of light reveals our homes huddled against a storm (*Farewell to Light*). A simple fence post cordons off the landscape to satisfy our desire for order (*Long Division*). A single combine at dusk works toward a visible, concrete purpose, racing against the rain (*Apparition*). There is a serenity here, where only nature, time, and the observer create the composition (*Heaven and Earth*).

As you consider the human element in the landscapes gathered in this book, please appreciate that these images record what generations of people working together over time and space have accomplished. There are no quirks of nature here, just the beauty of firmly grounded communities working in unison to solve problems, to create solutions.

In assembling this collection I have tried to highlight the presence of people and the beauty of time as it relates to the midwestern landscape. Through all the changes, what remains, as if an old friend, is the earth, the sky, and the soul of the people living in harmony on this firm ground.

ON FIRM GROUND

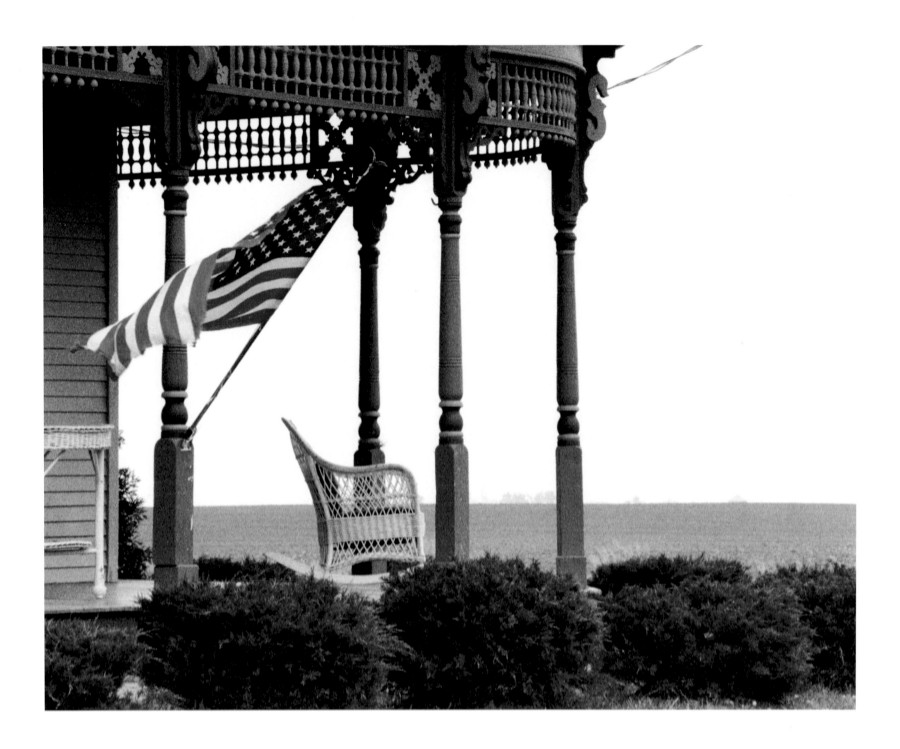

1. American View

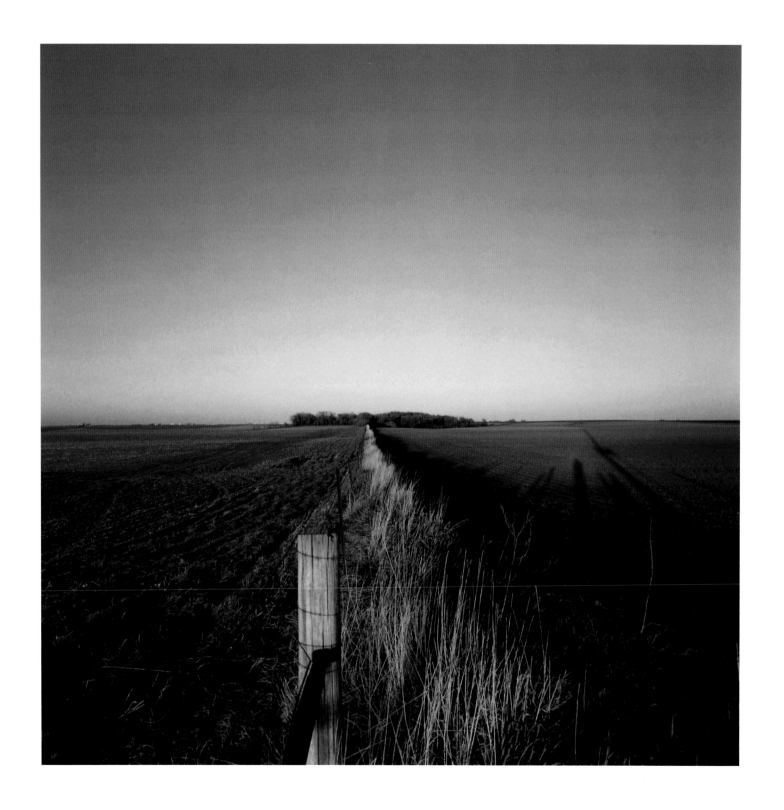

2. Long Division

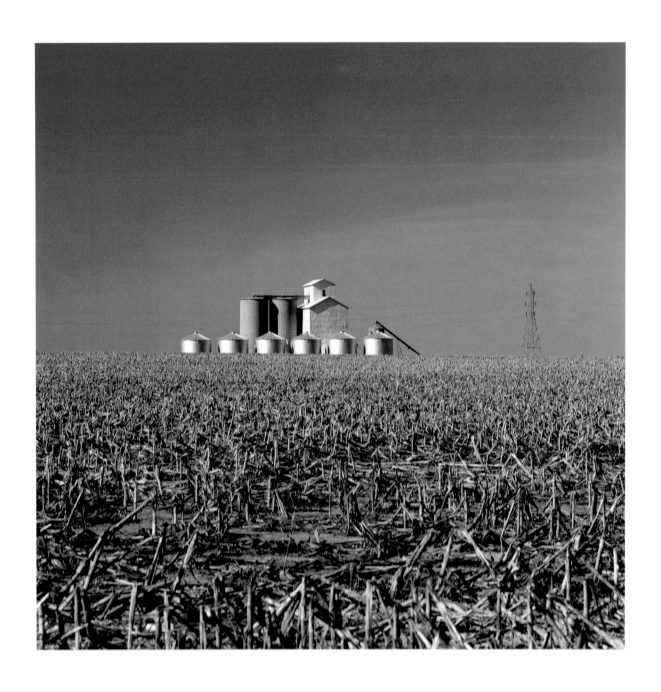

3. Islands in the Corn

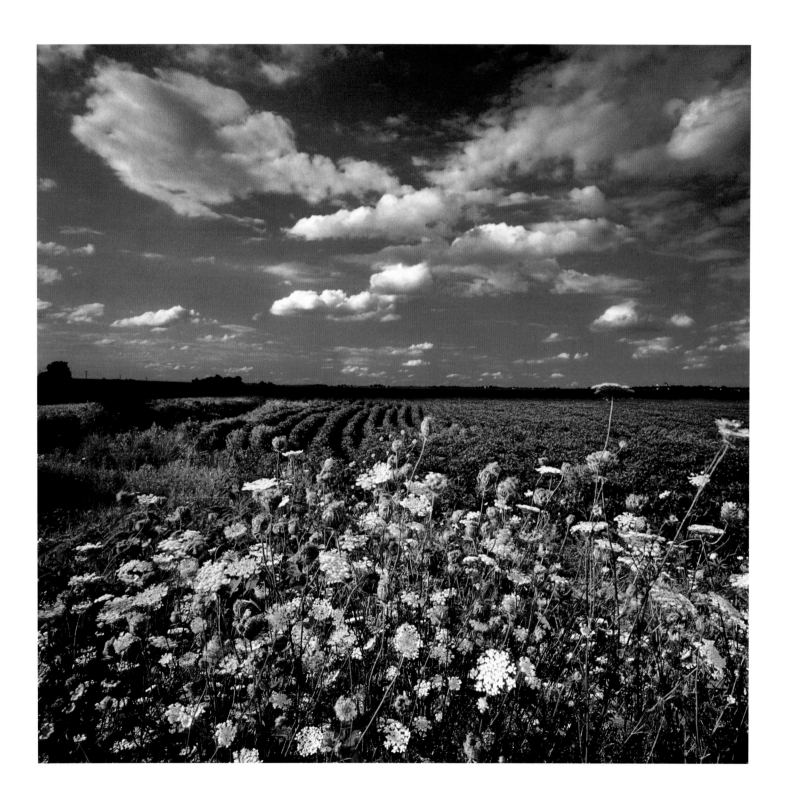

4. Queen Anne's Festival

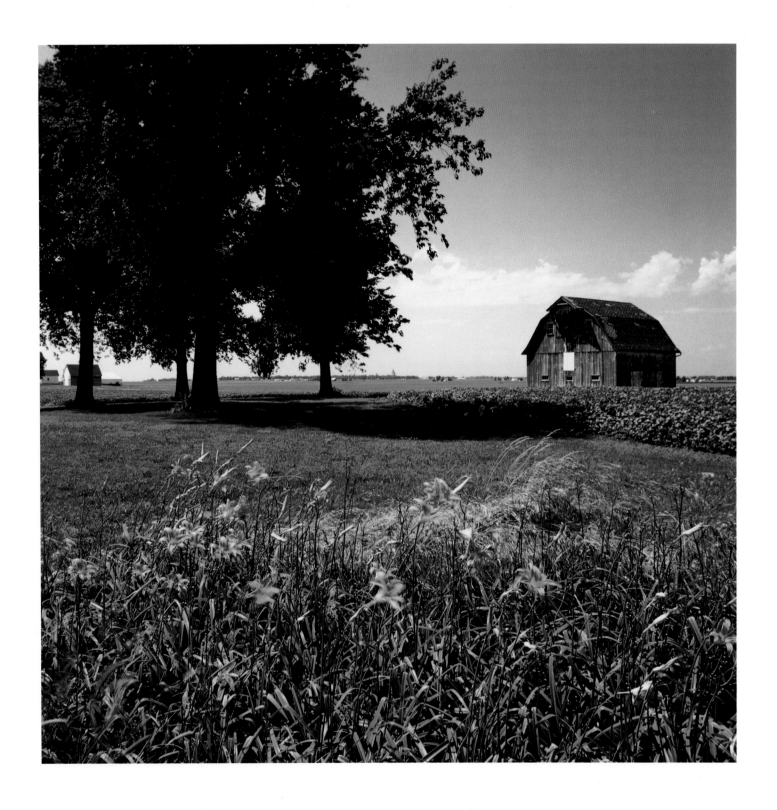

5. Philo Summer

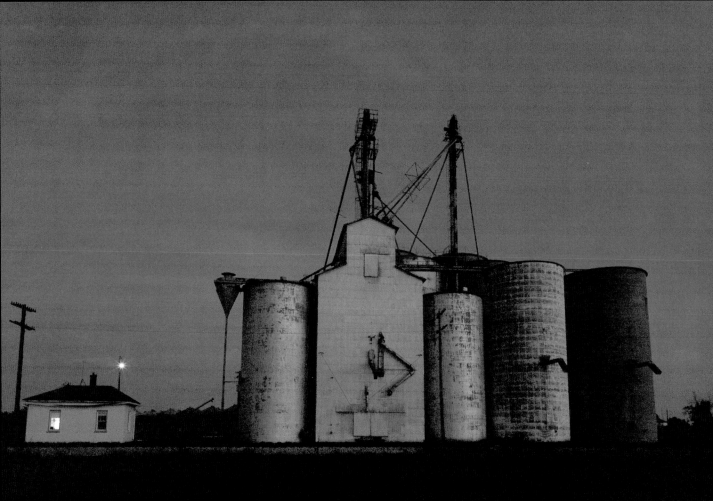

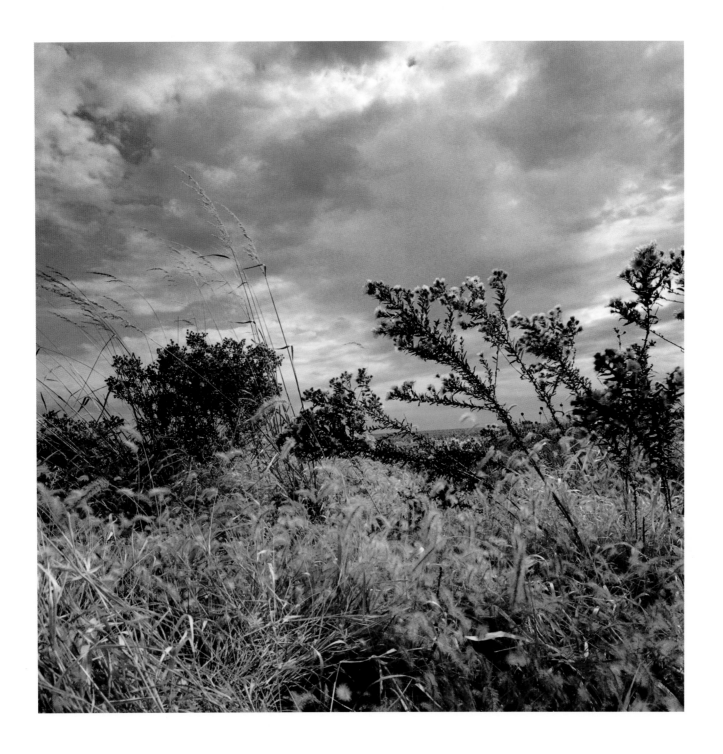

7. Arabesque

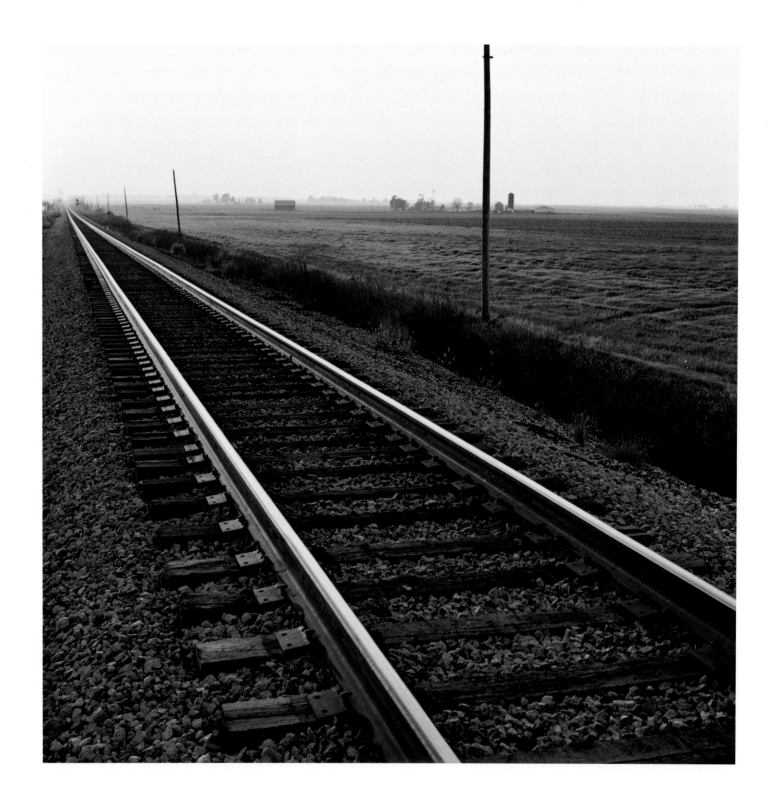

8. Guiding Light

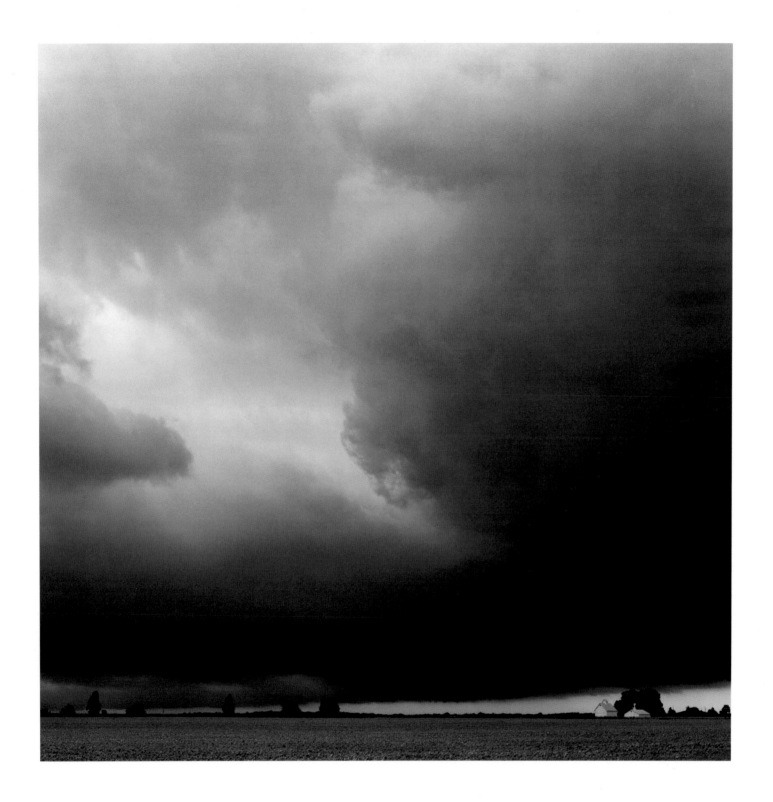

9. Farewell to Light

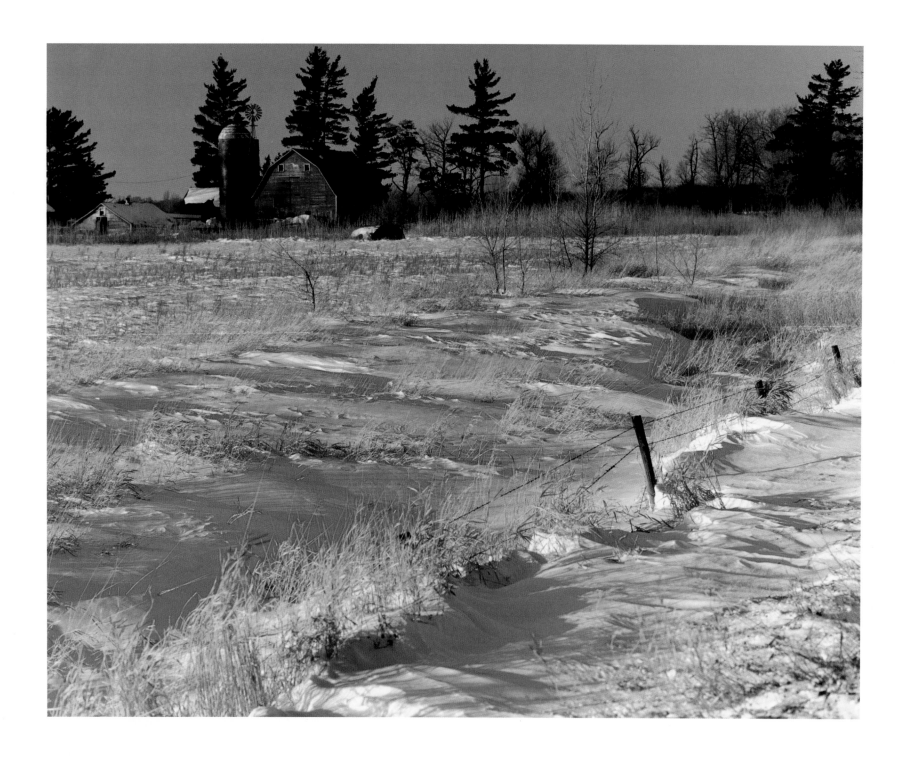

10. Homesteader

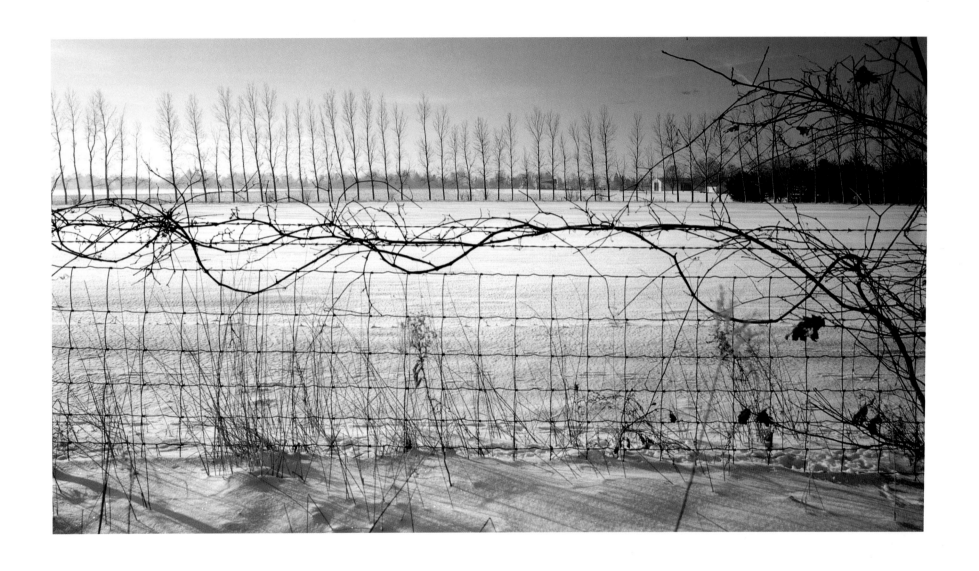

11. Rhythm and Blue

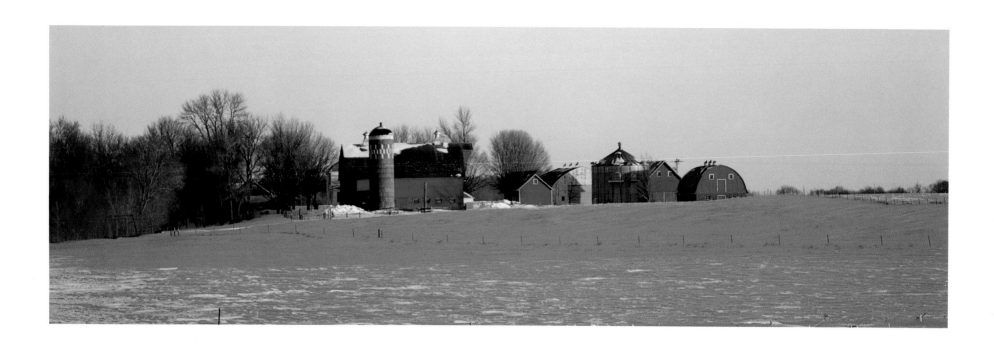

12. Somewhere in Time

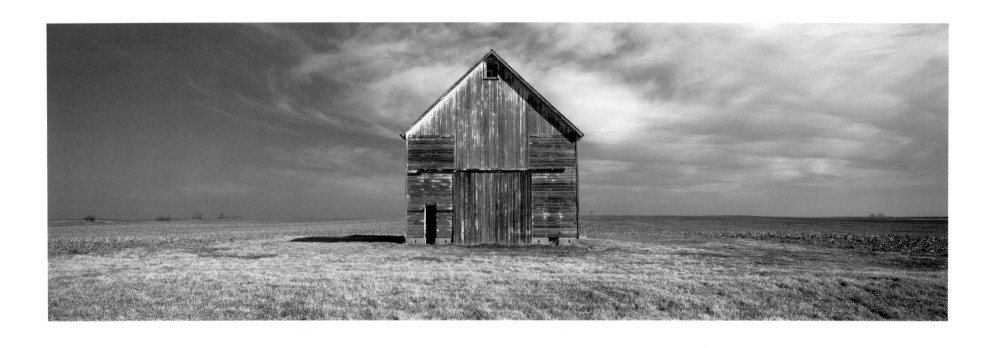

13. Stalwart

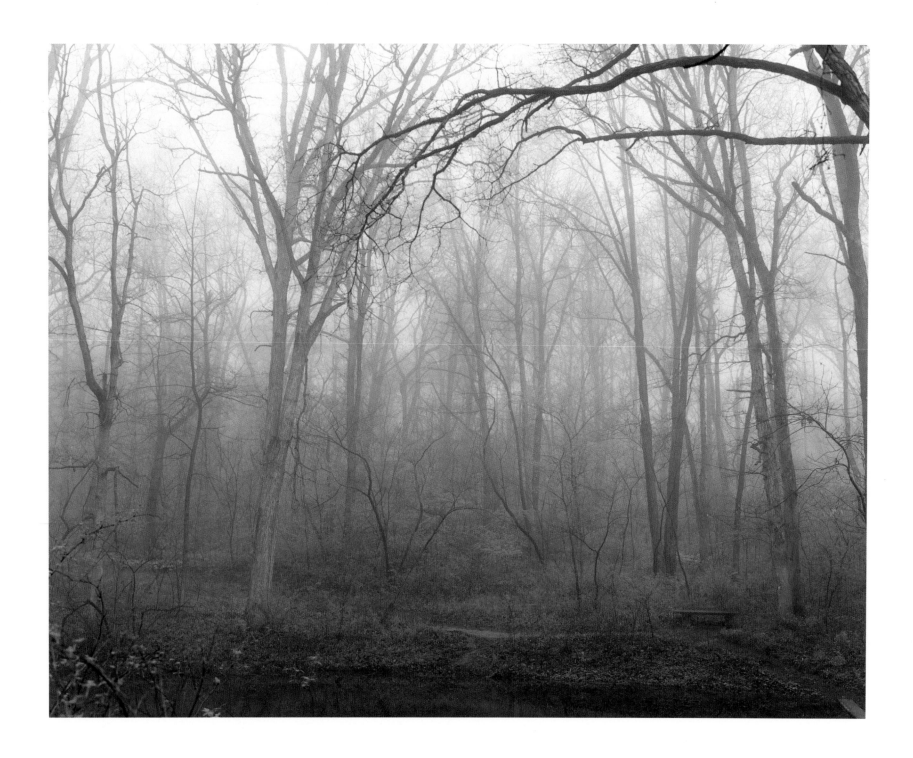

14. Forgotten Footpaths

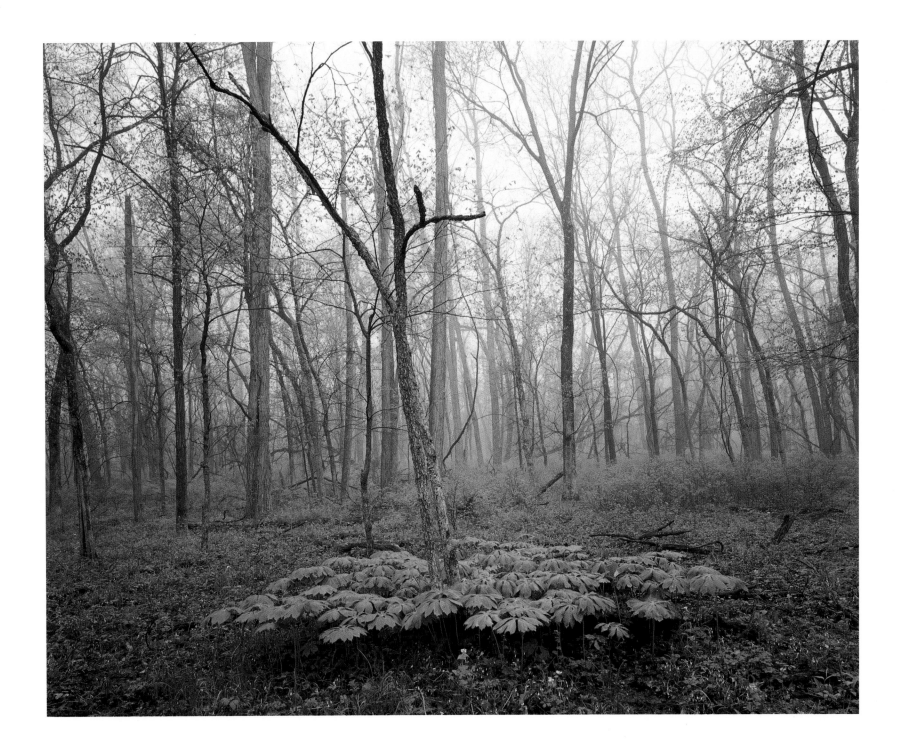

15. Umbrella Stand

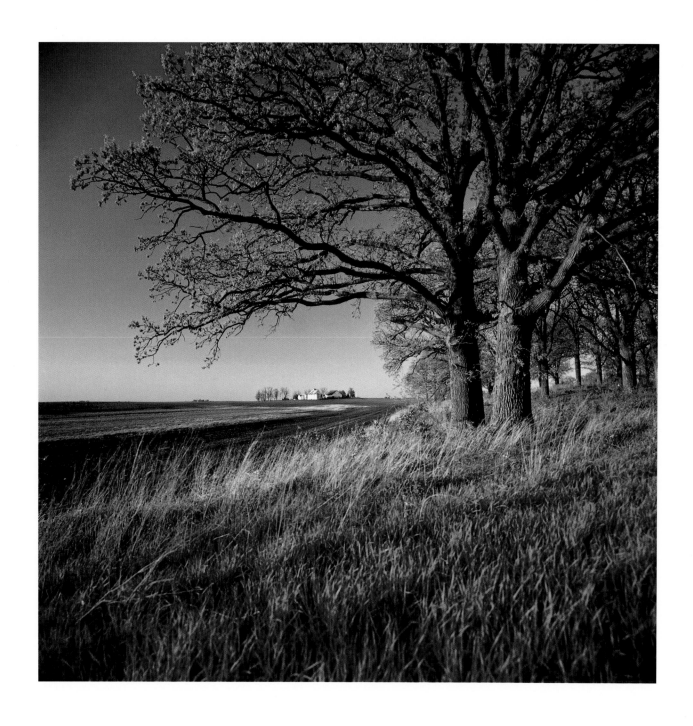

16. Grandfather's Grove

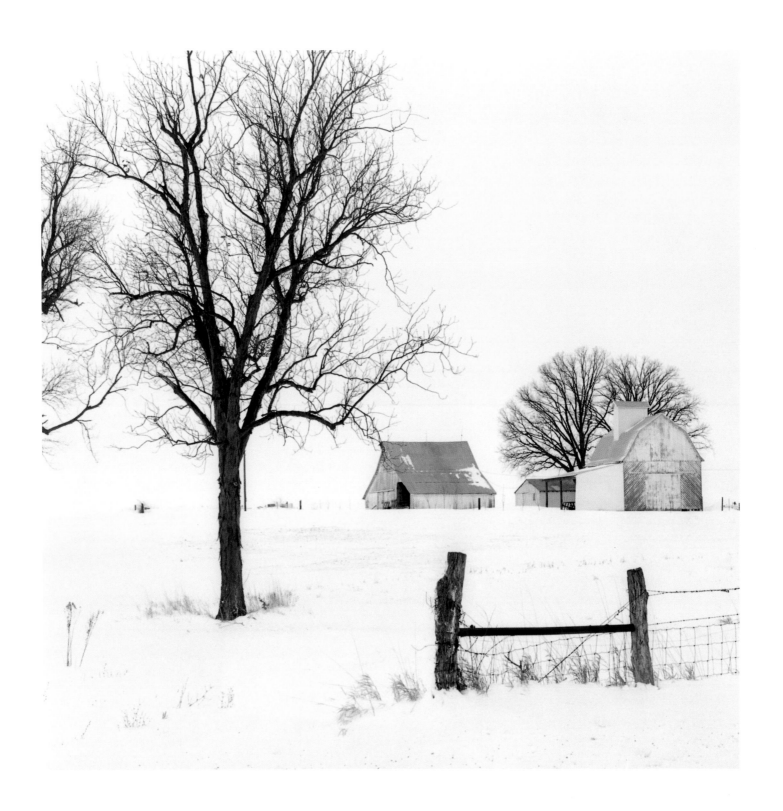

17. Undisturbed

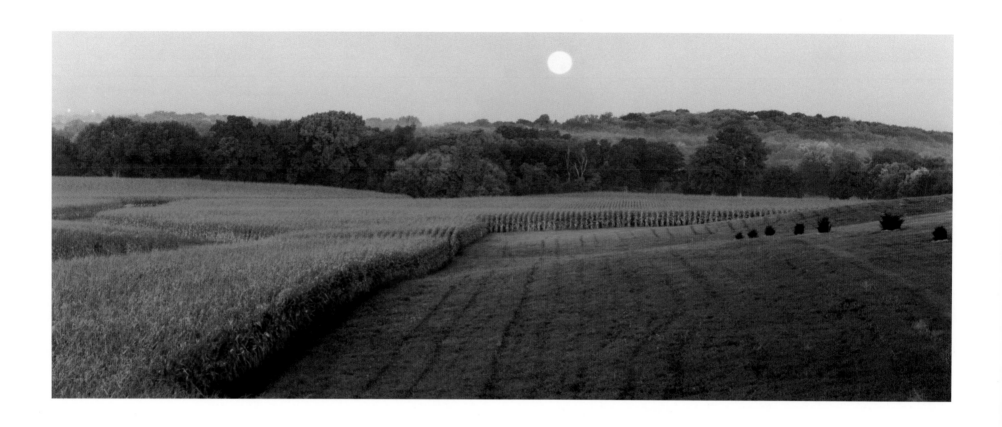

18. Moonlit Crescendo

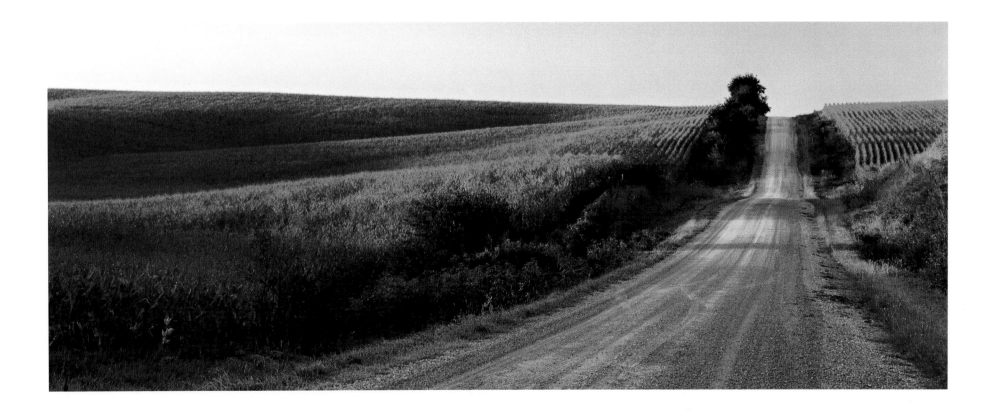

19. Over the Edge

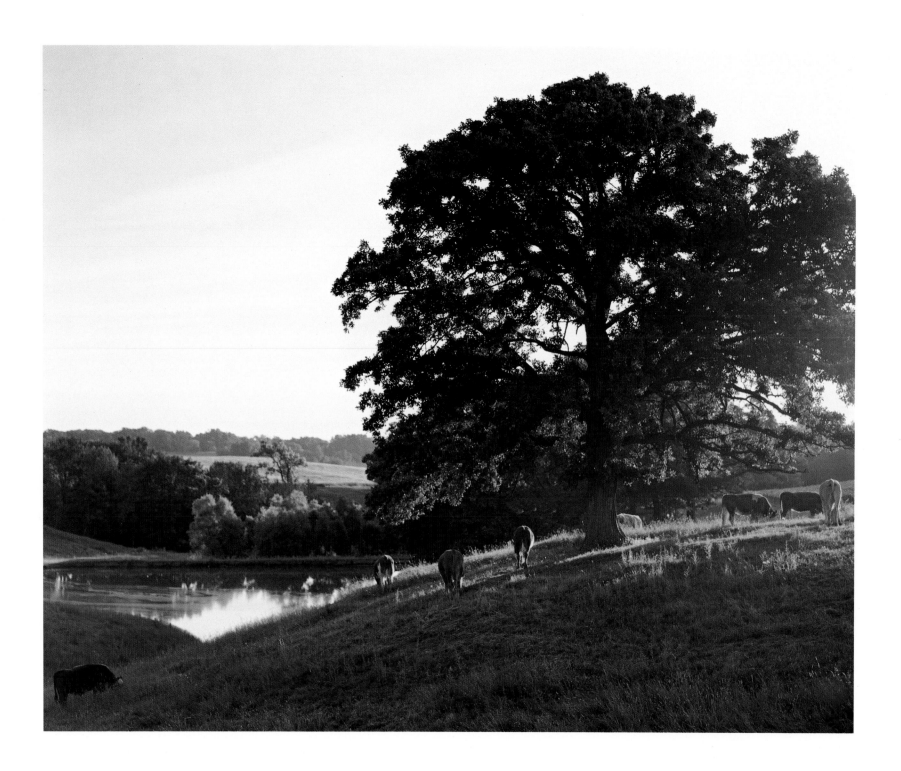

20. Lazy Afternoon

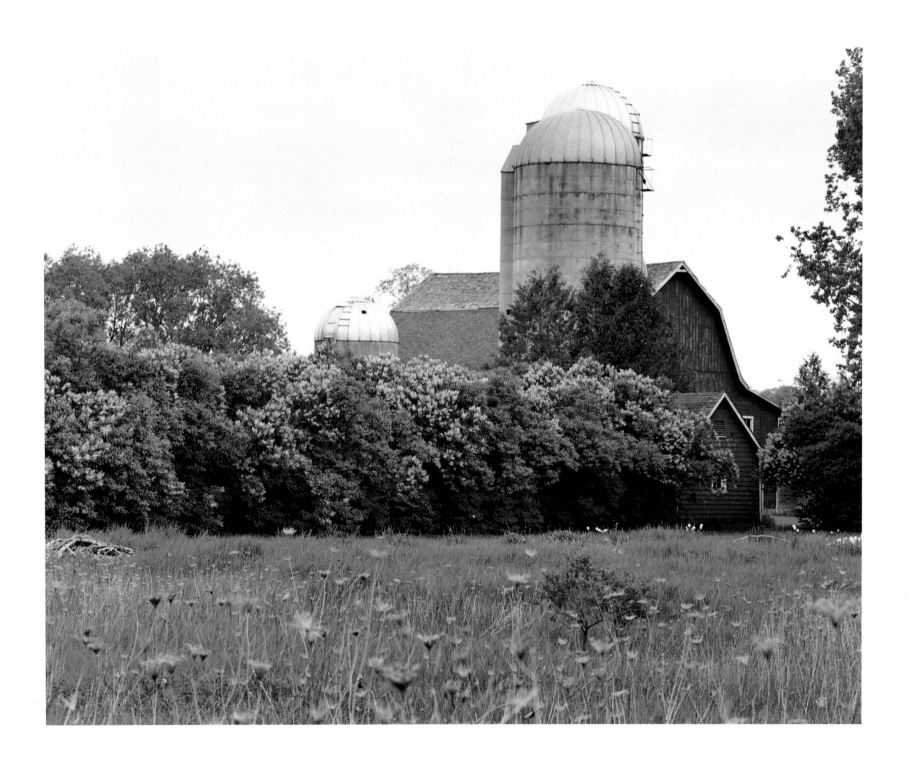

21. American Classic

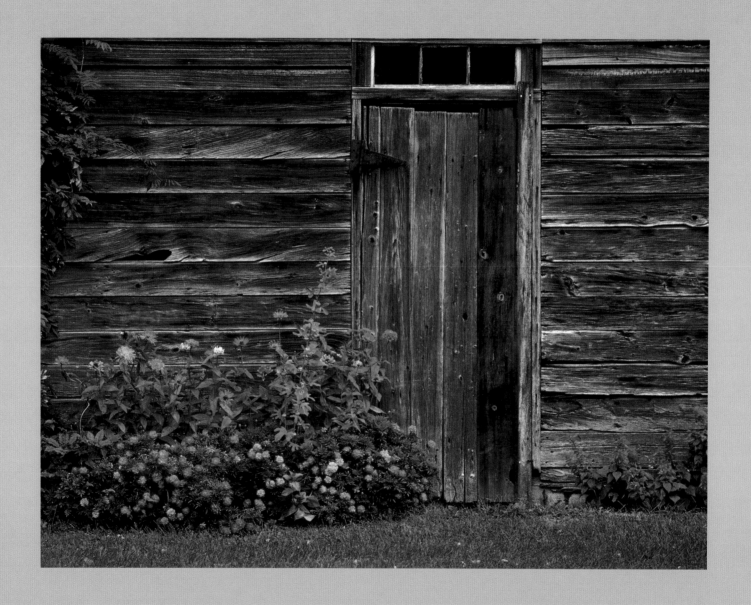

22. Pioneer Pride

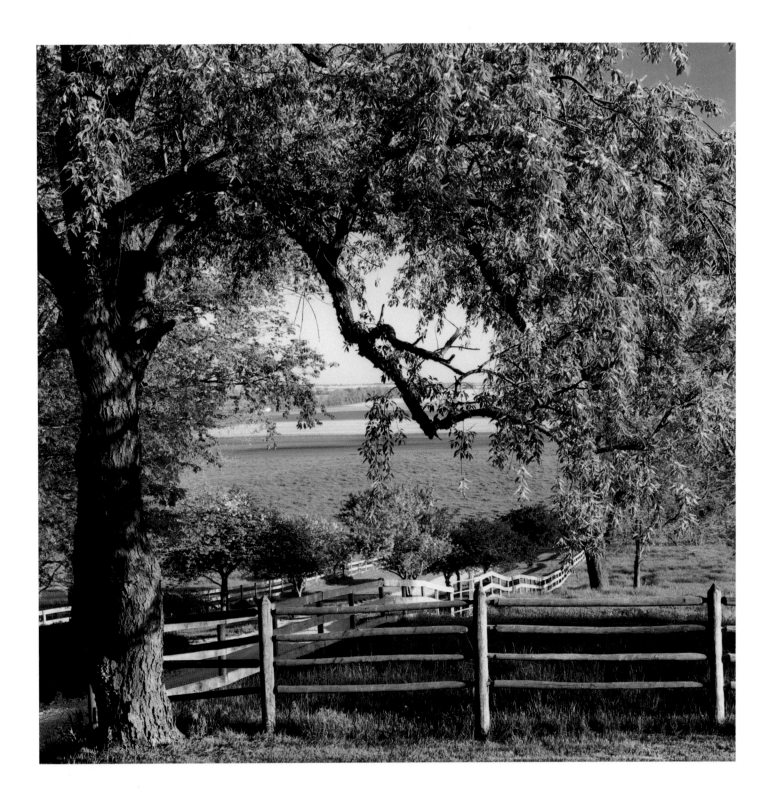

23. Sunday Dreamer

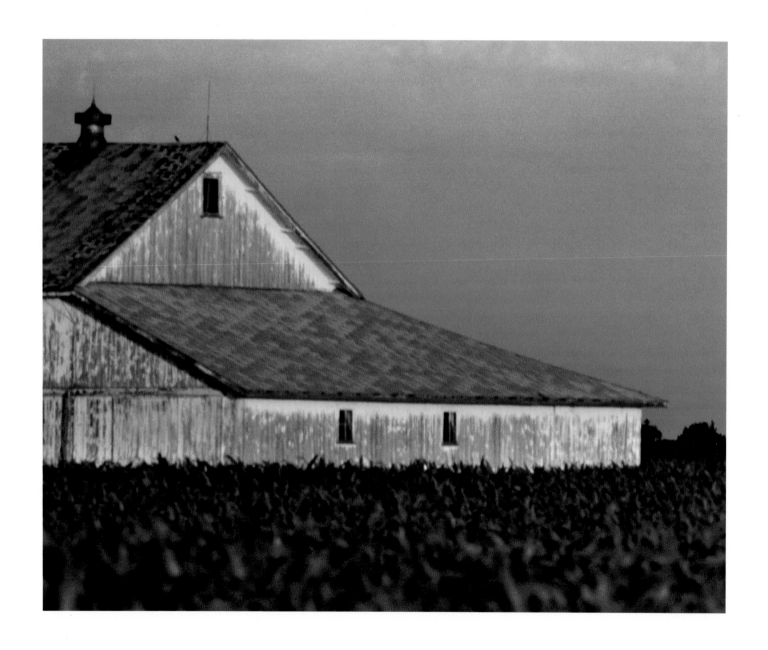

24. Prairie Gothic

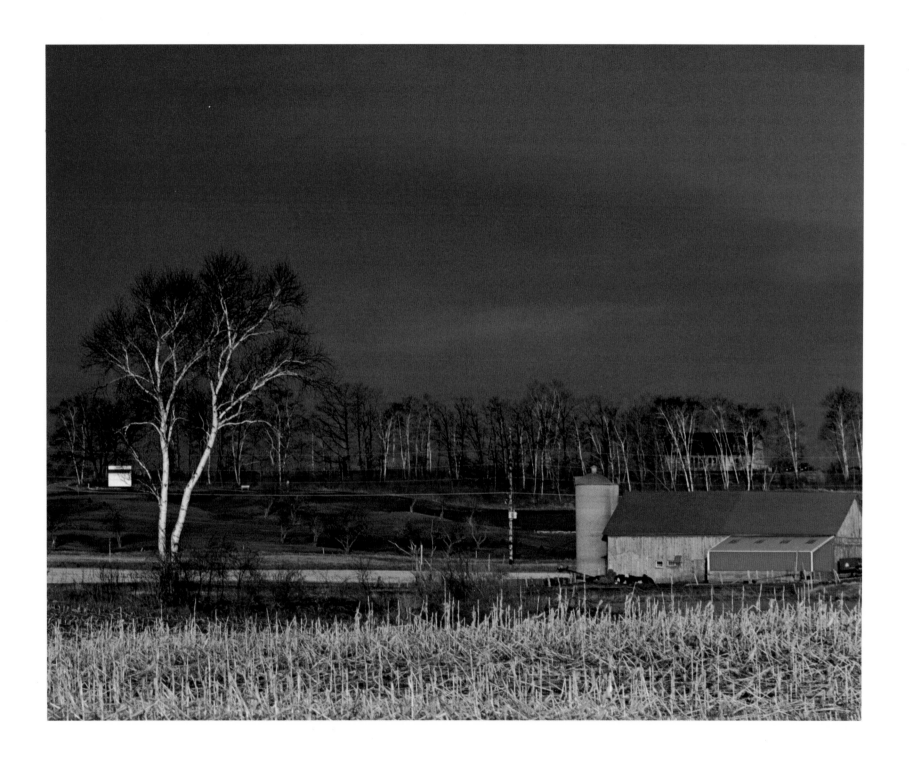

25. Before the Rain

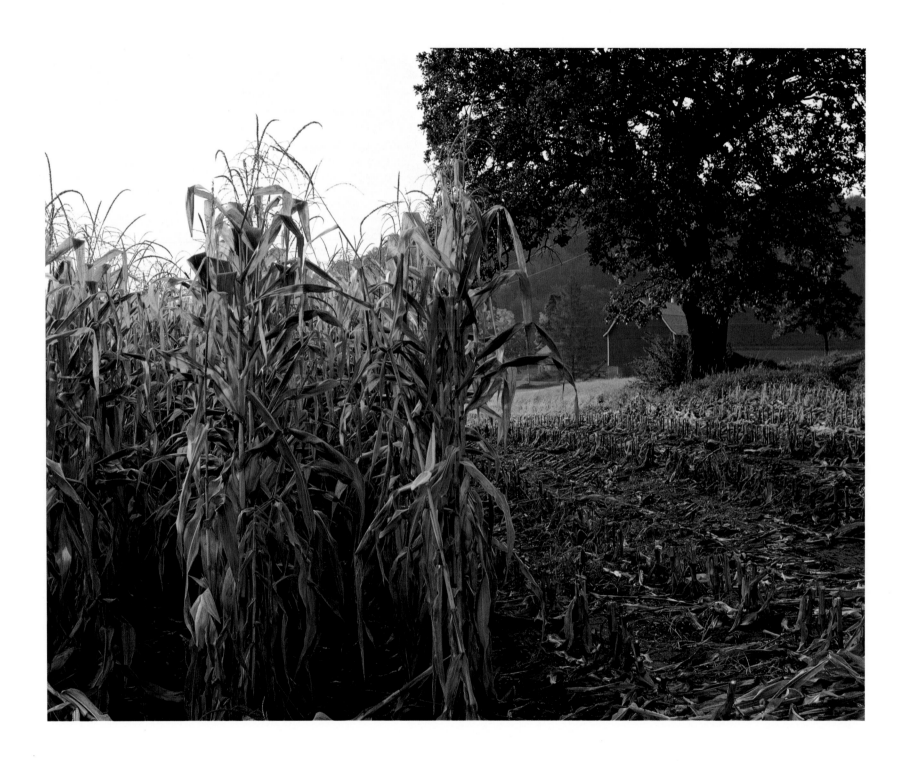

26. Fall Farewell

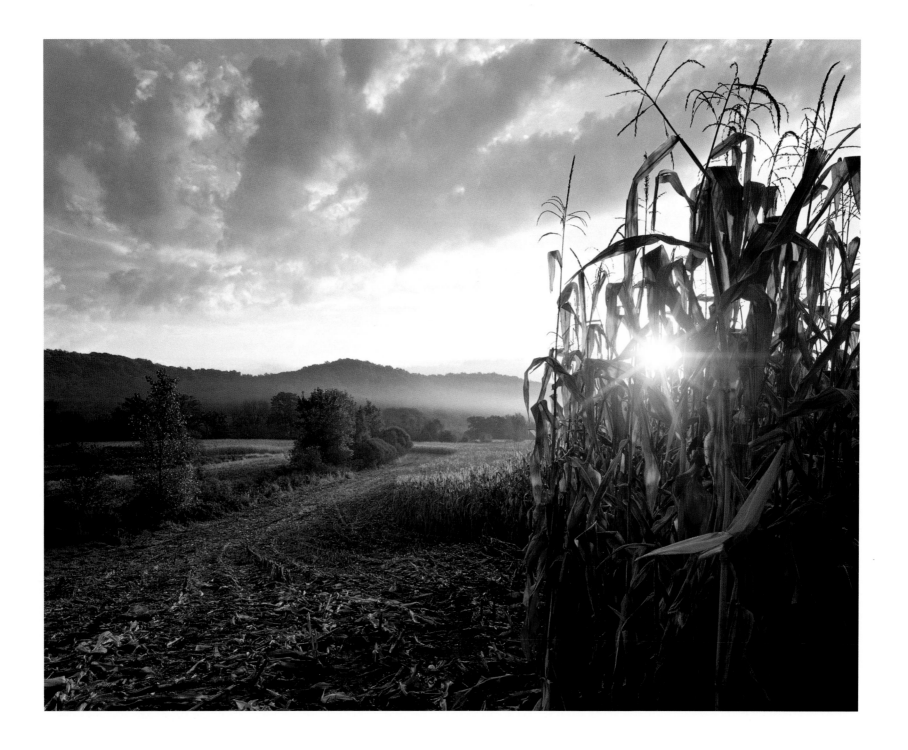

27. Full Circle

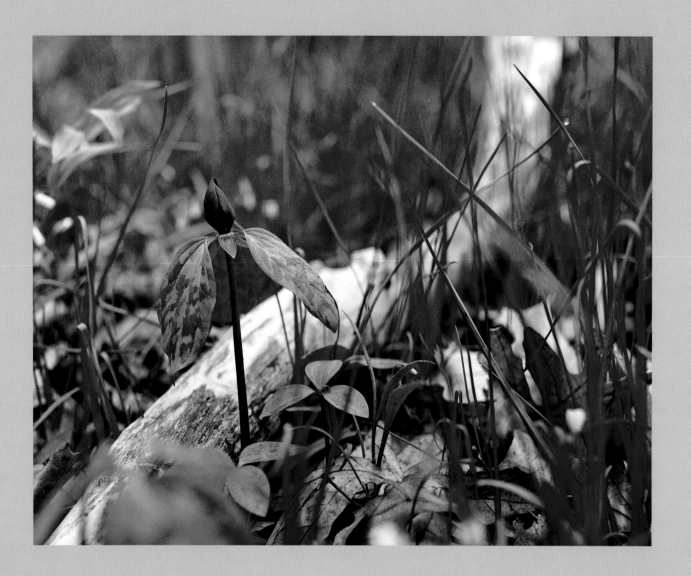

28. Trillium

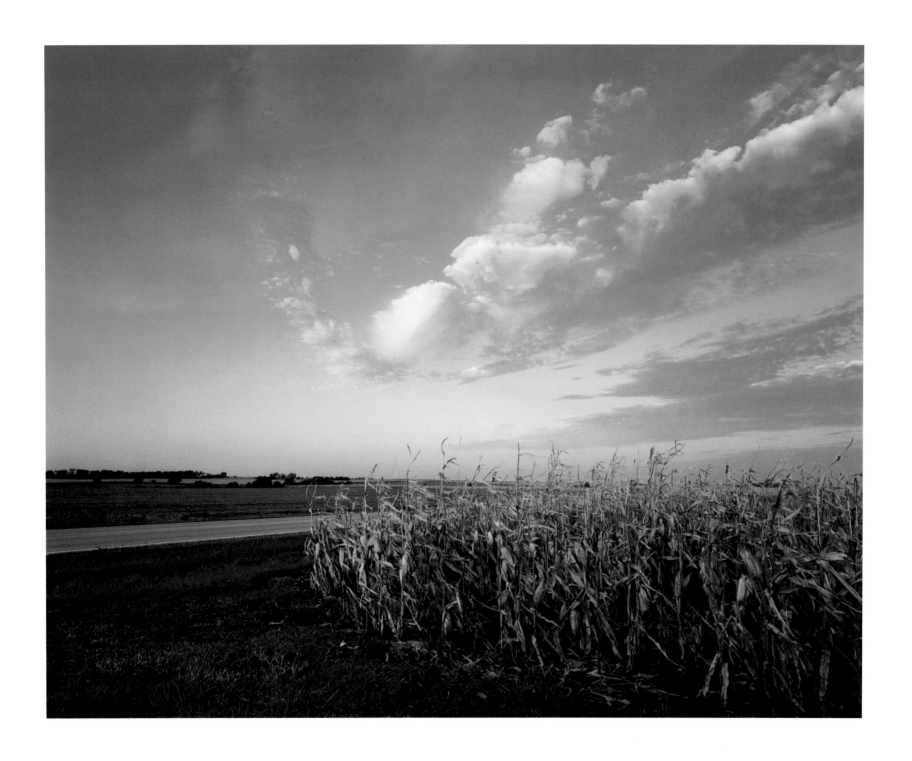

29. Heaven and Earth

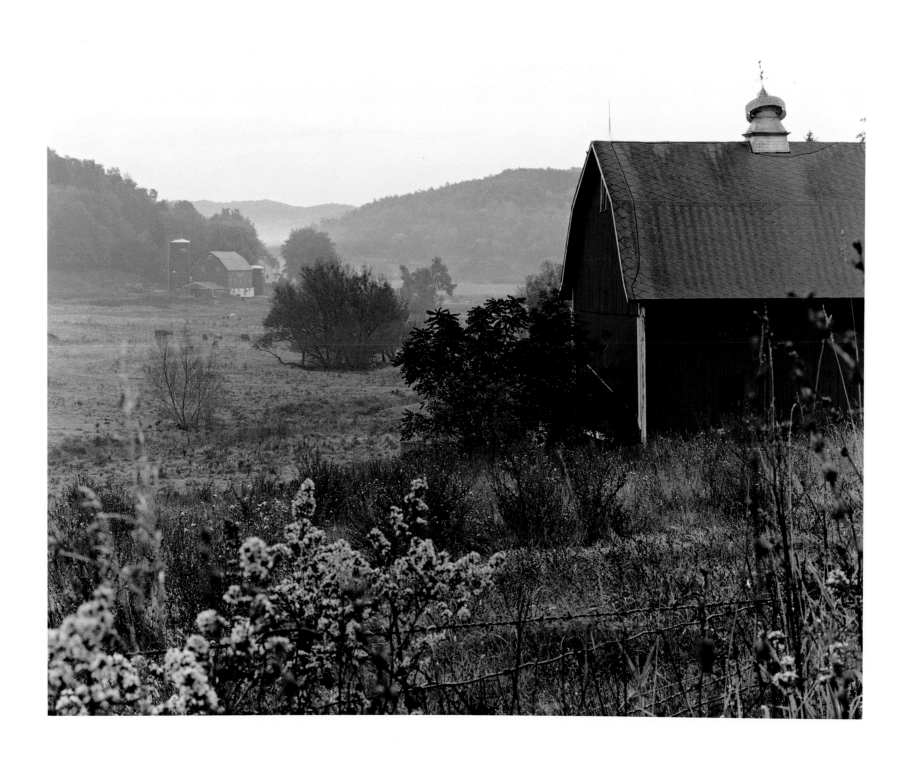

30. Good Neighbors

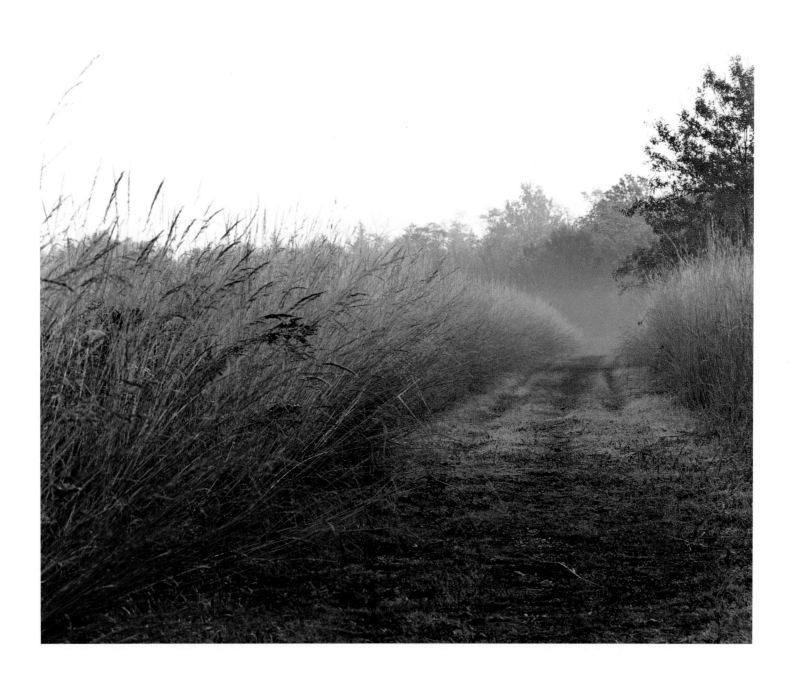

31. Autumn Allerton Morning

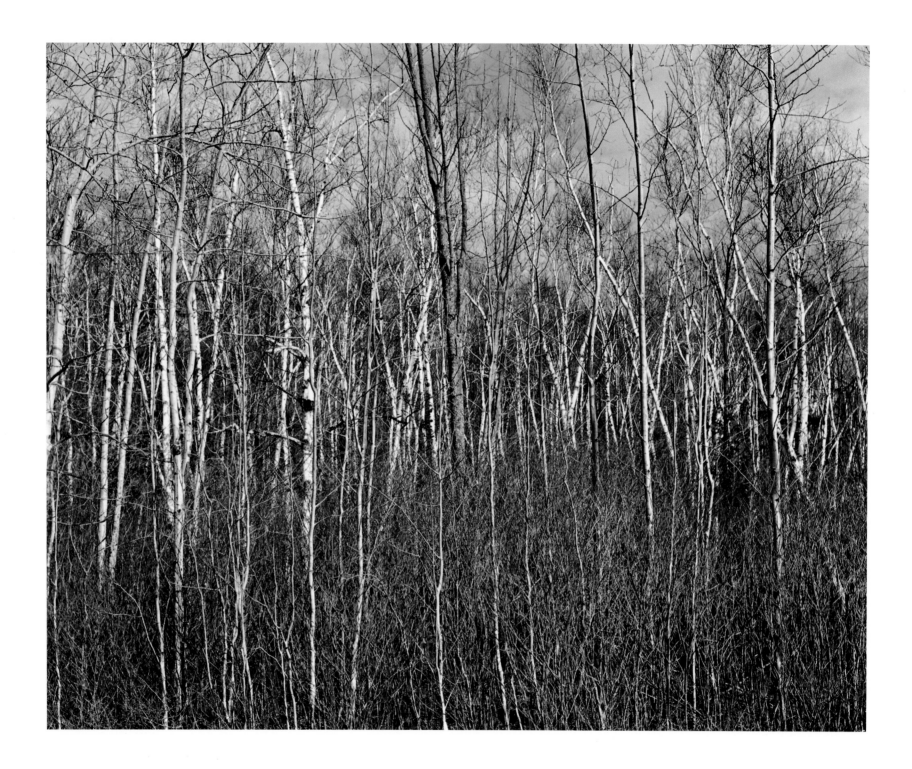

32. Silver Strands

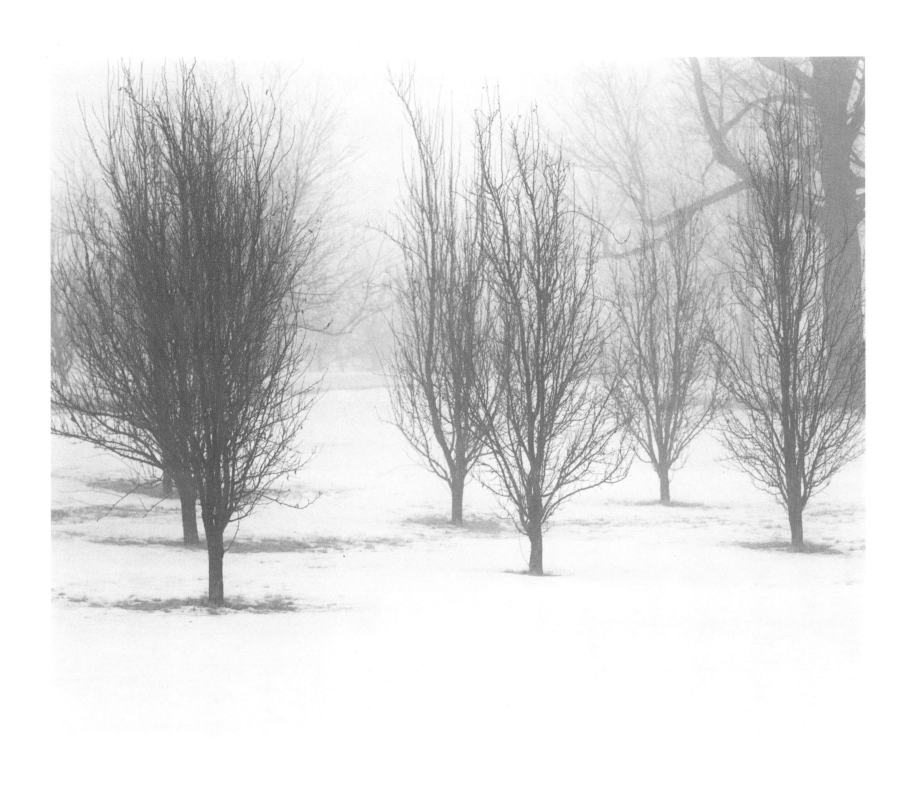

33. January Thaw

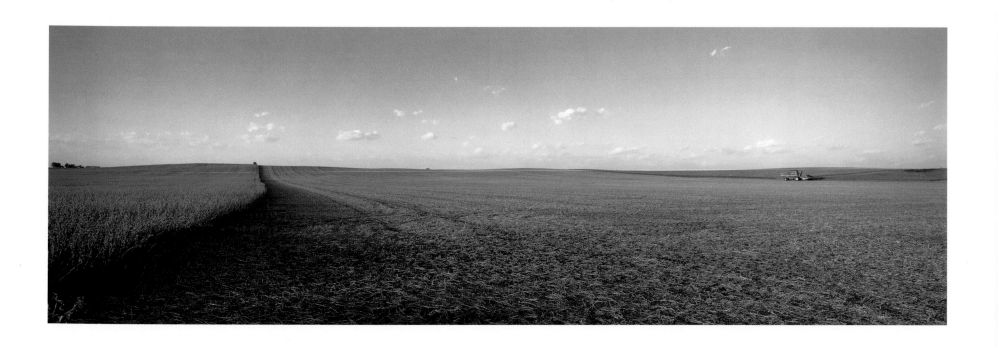

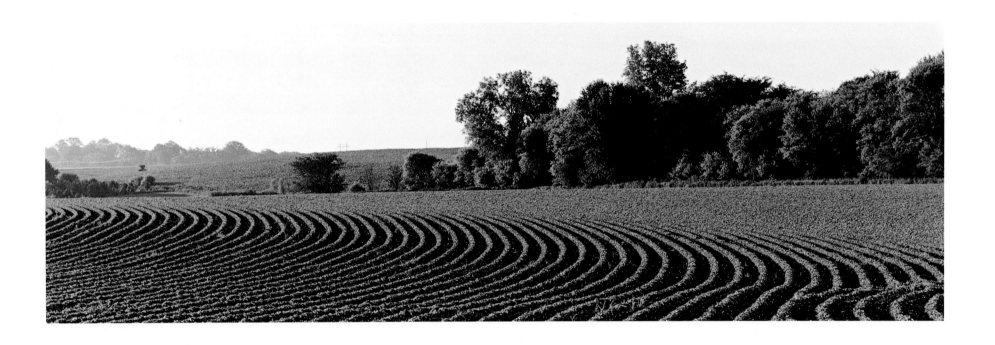

35. Crown Jewels

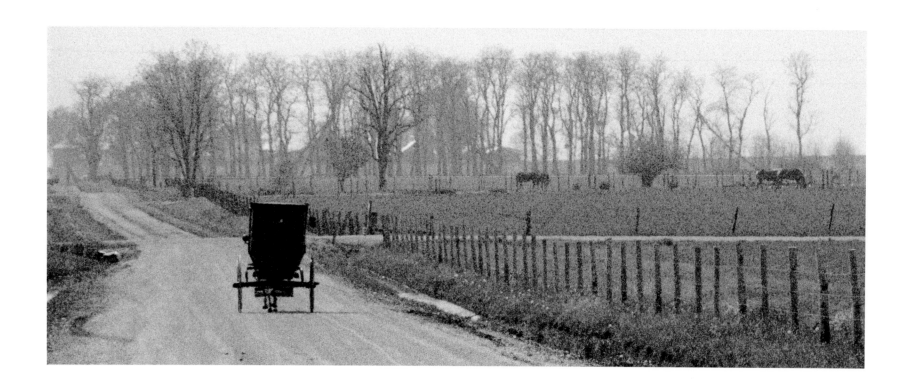

36. Road to the Millers

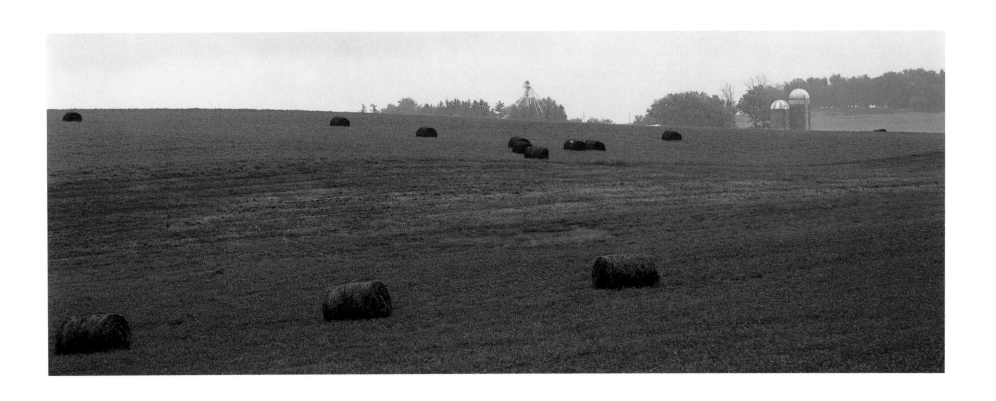

37. Greener Pastures

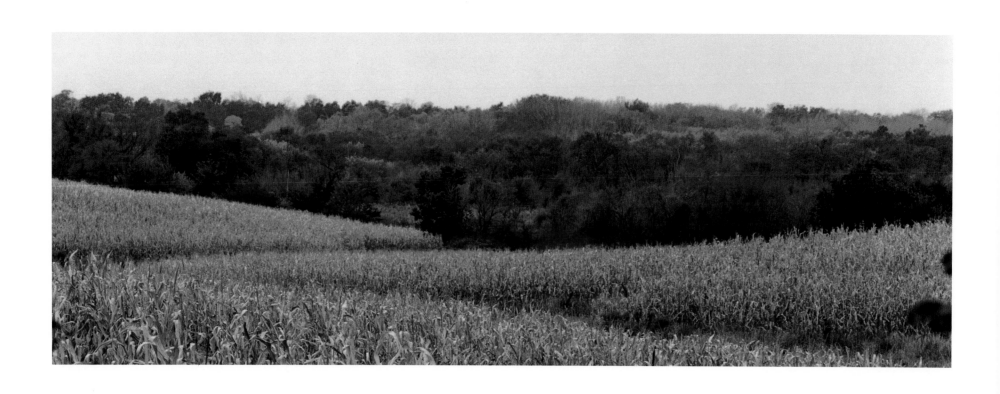

38. Harvest Blend

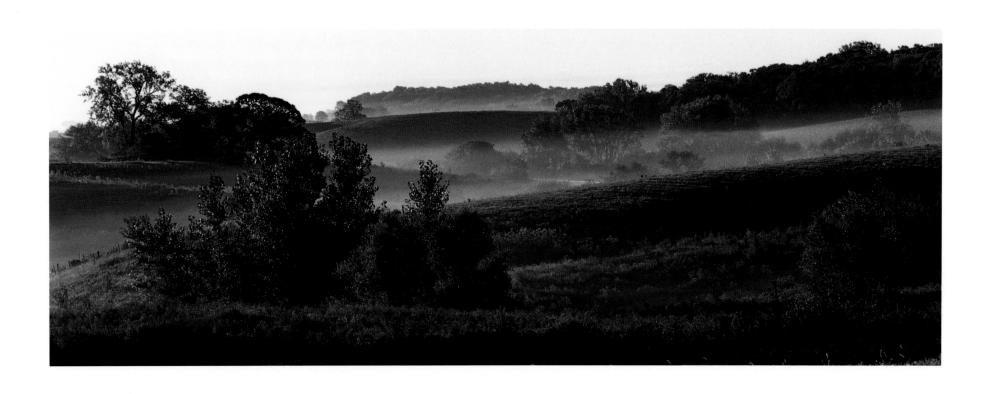

39. Evanescent Tapestry

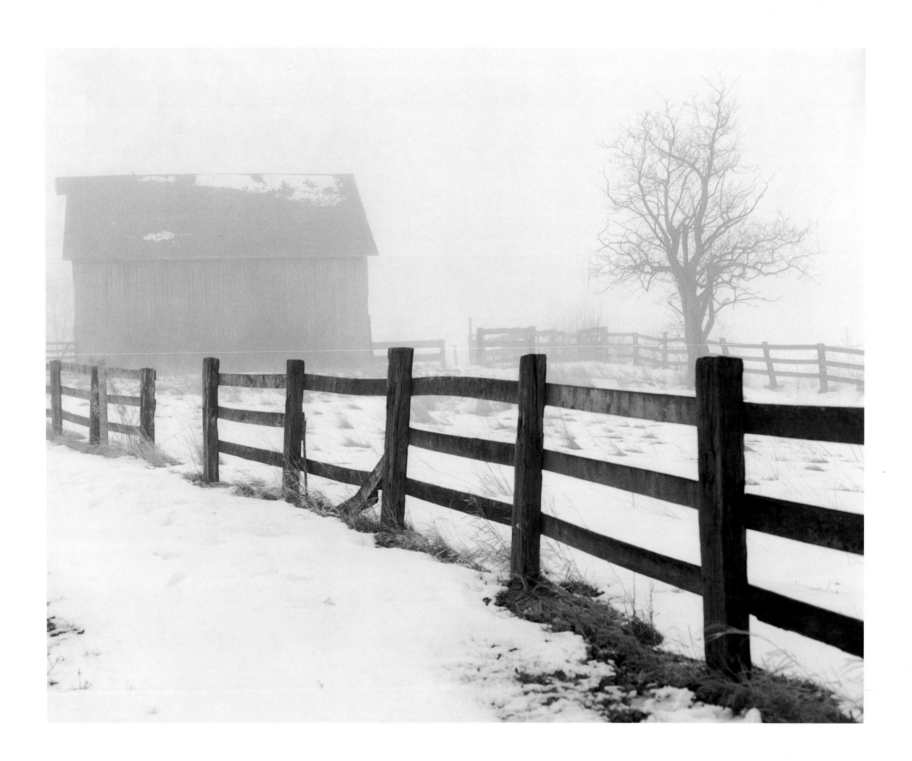

40. Solitude Transcended

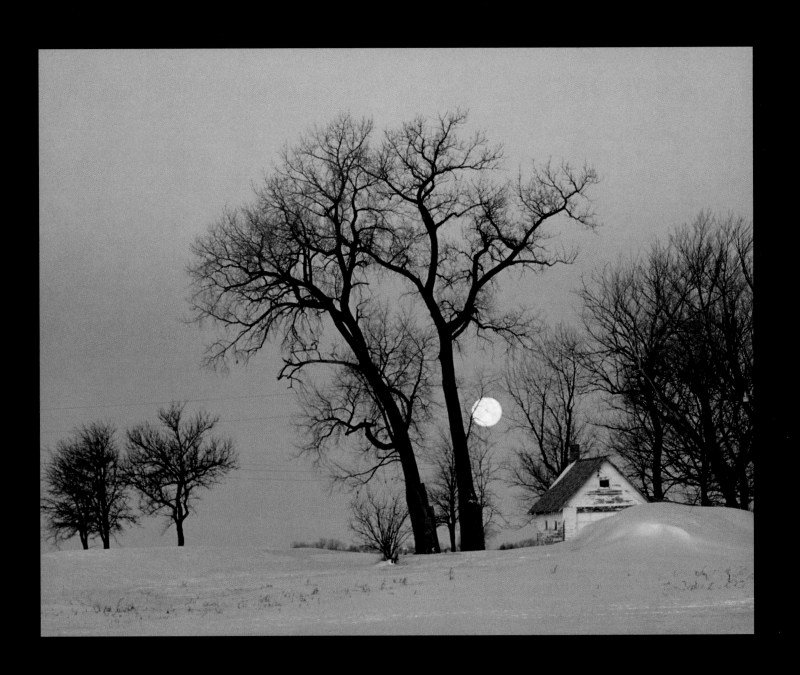

41. By the Light of the Silvery Moon

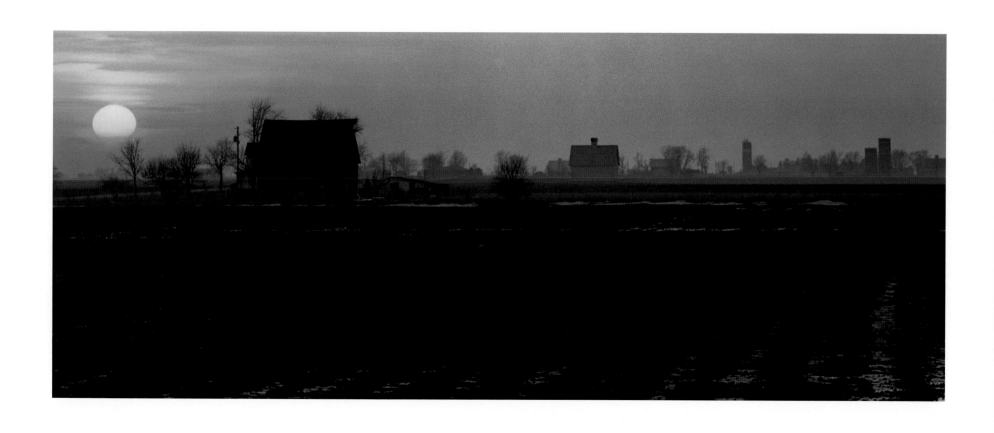

42. Approaching Light

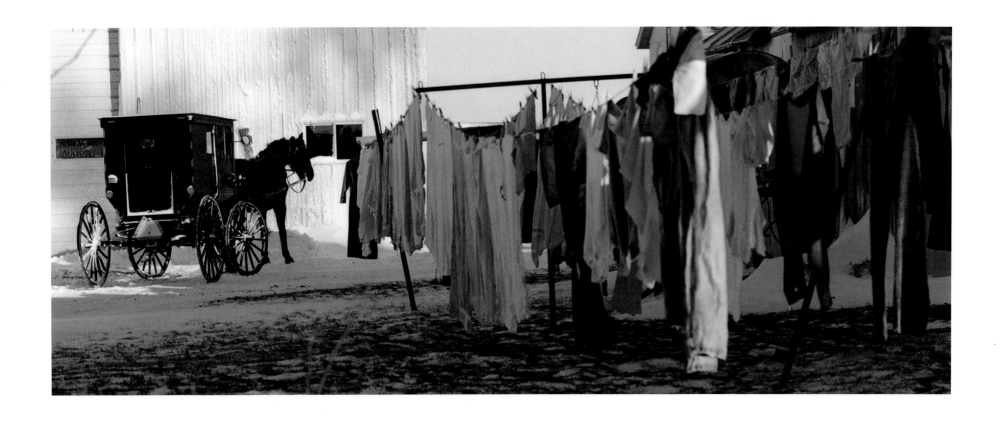

43. Bare Necessities

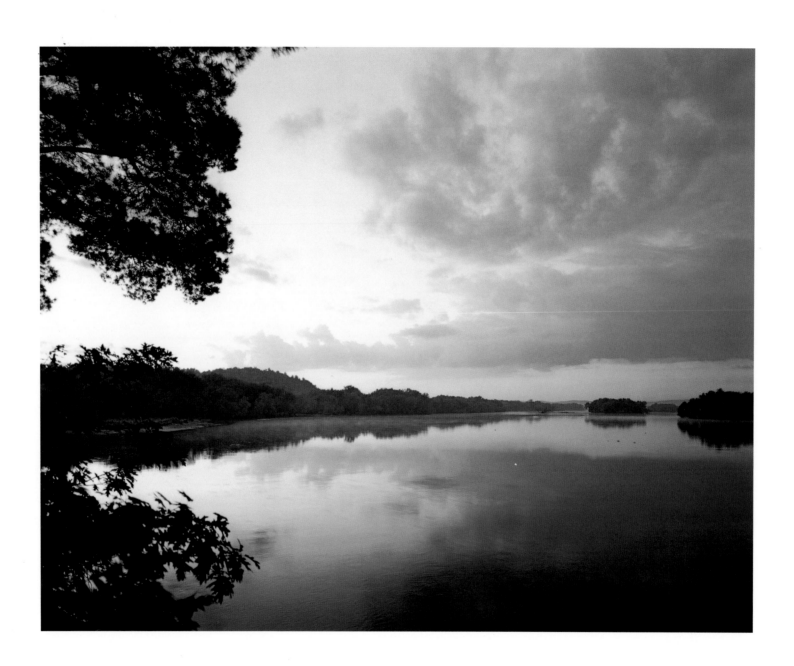

44. The River

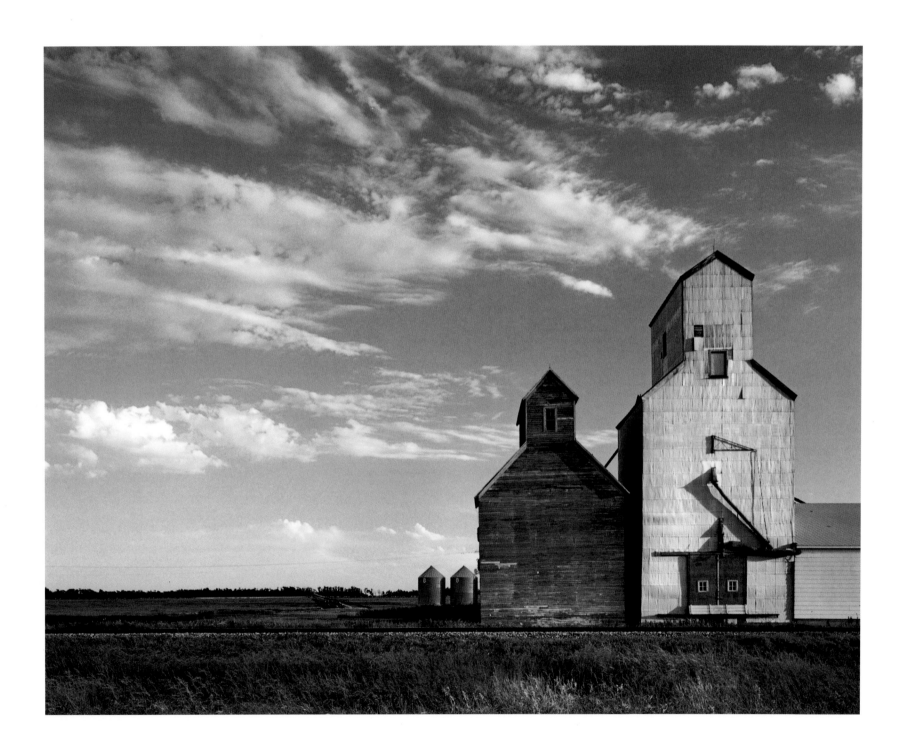

45. Watching the Rail

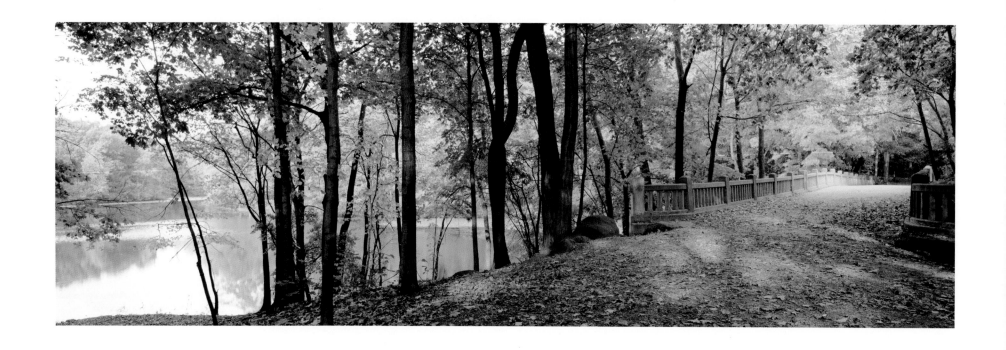

46. Riversong

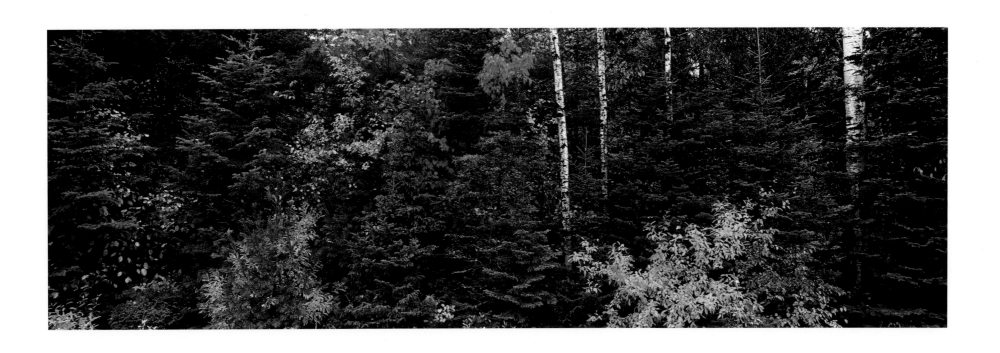

47. Valentine Woods

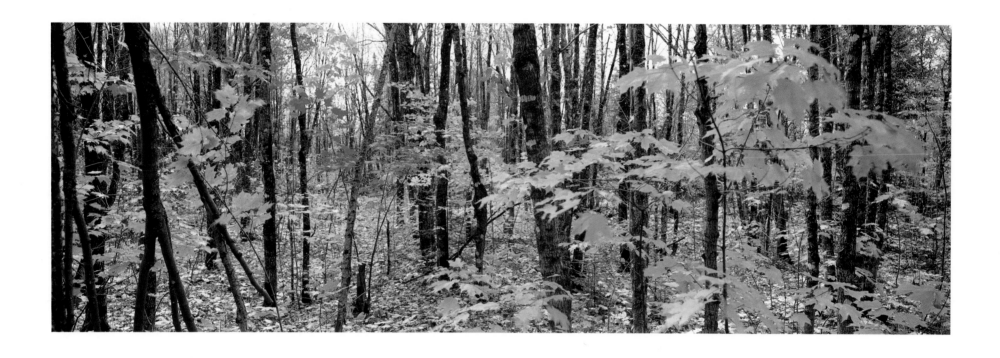

48. Fall Recital

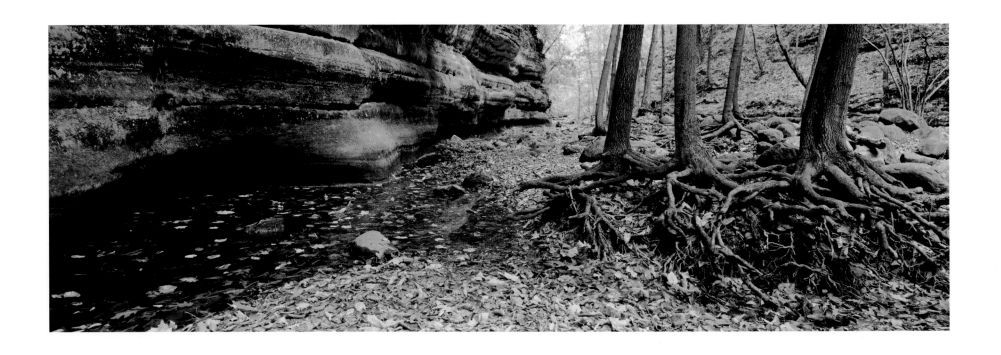

49. Canyon Dance

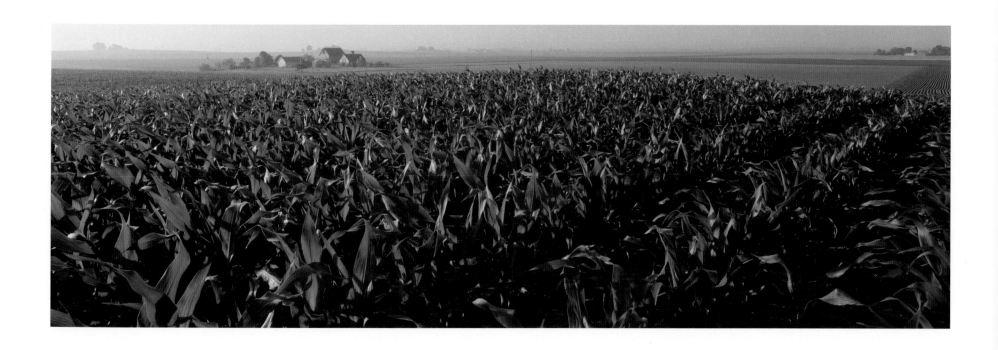

50. Standing Ovation

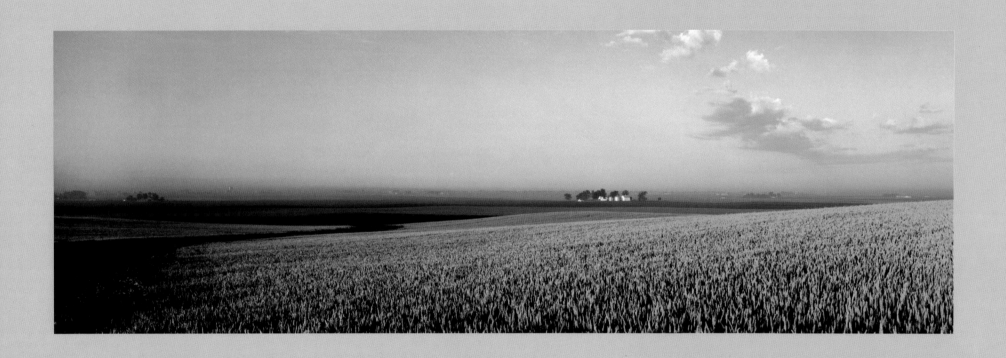

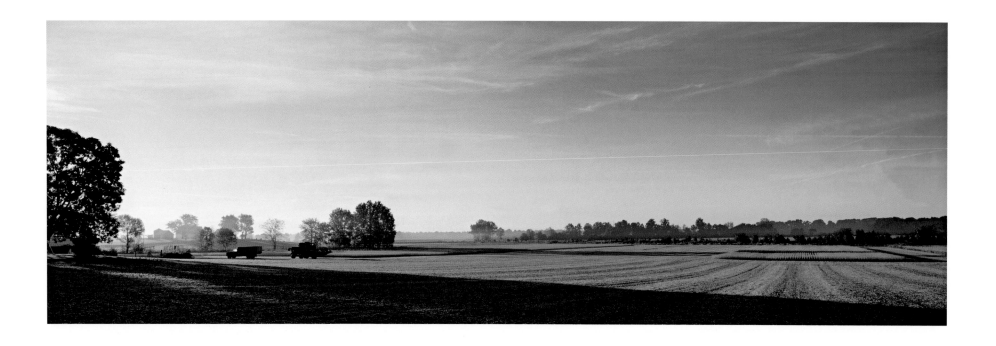

52. Finish Line

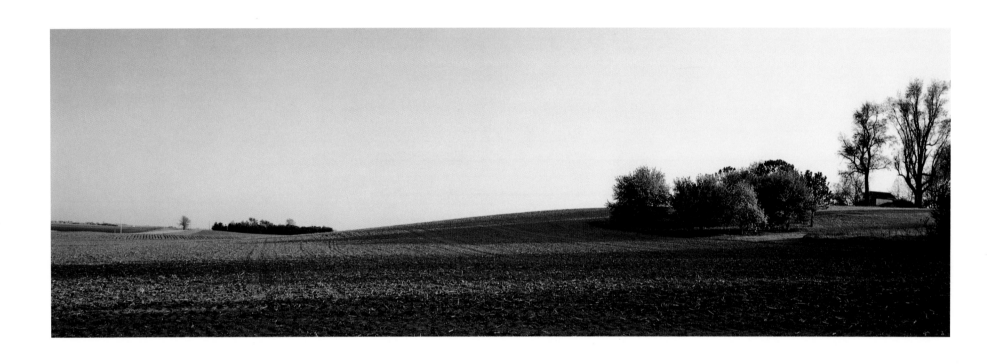

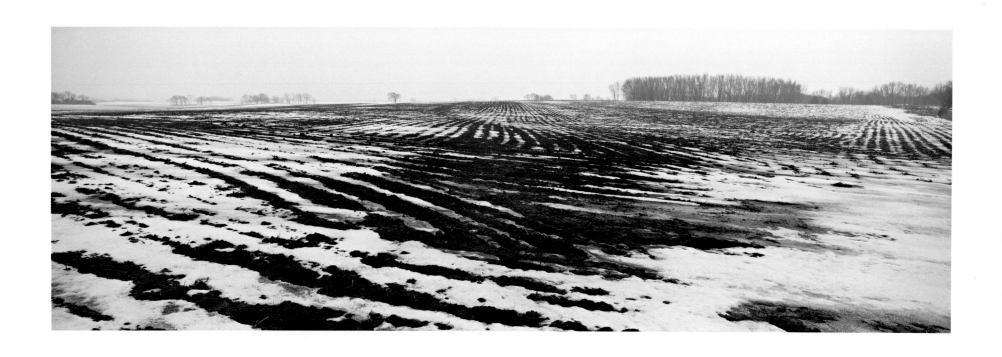

54. The Groundbreaking

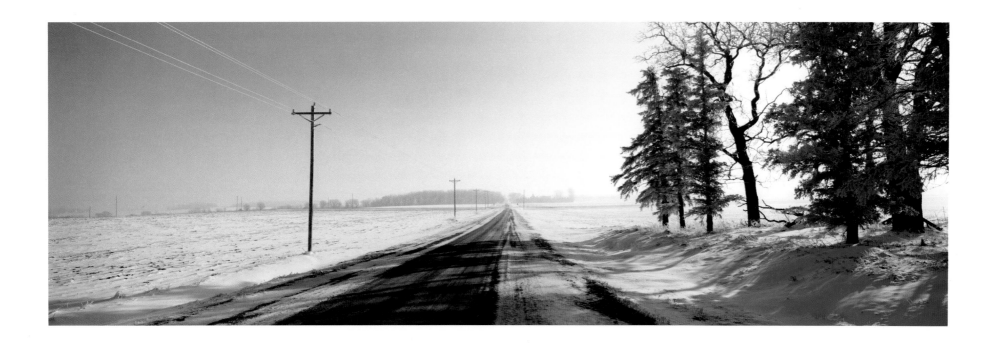

55. Solitary Passage

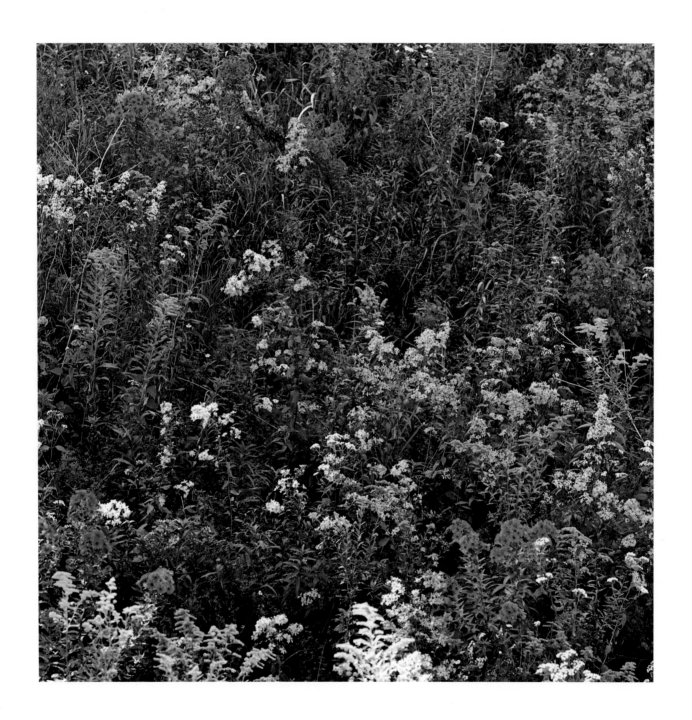

56. Roadside Bouquet

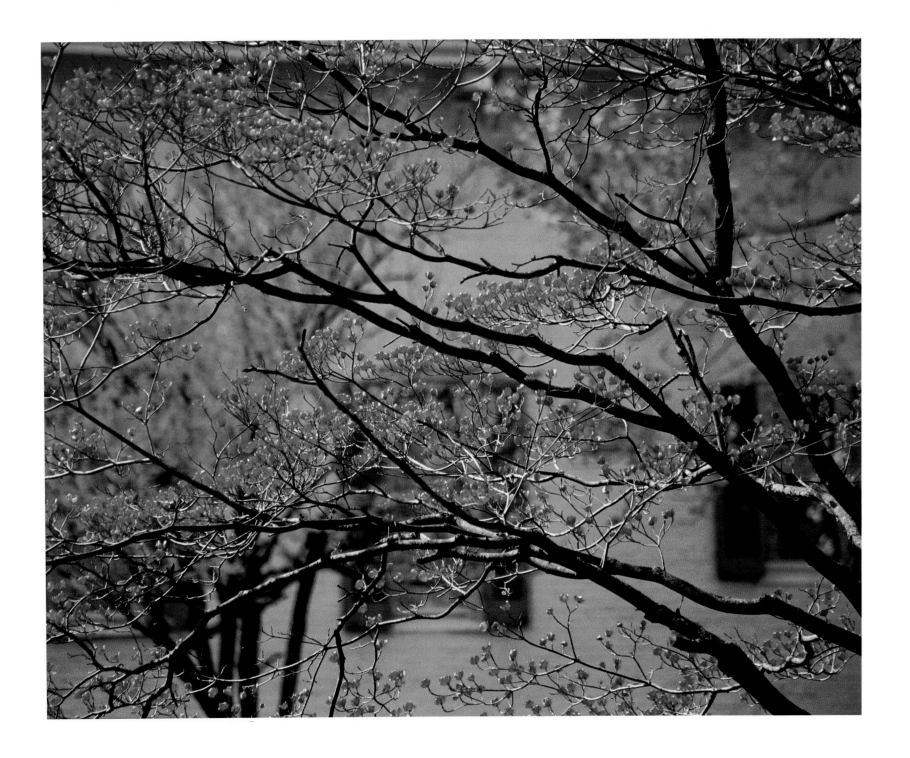

57. Dogwood Dance

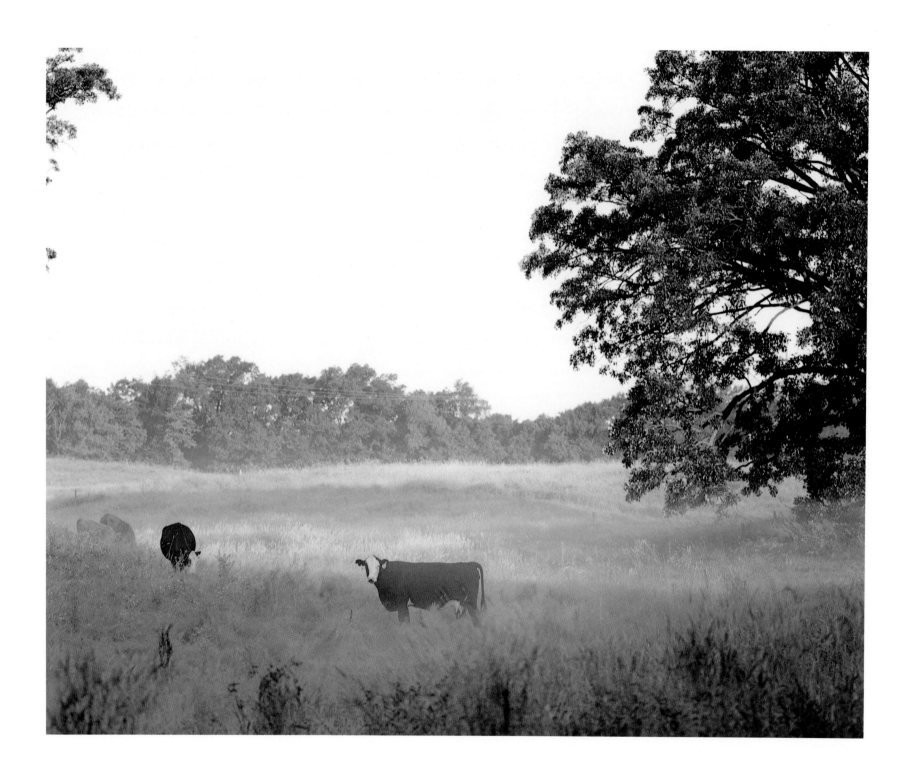

58. Hey Diddle Diddle

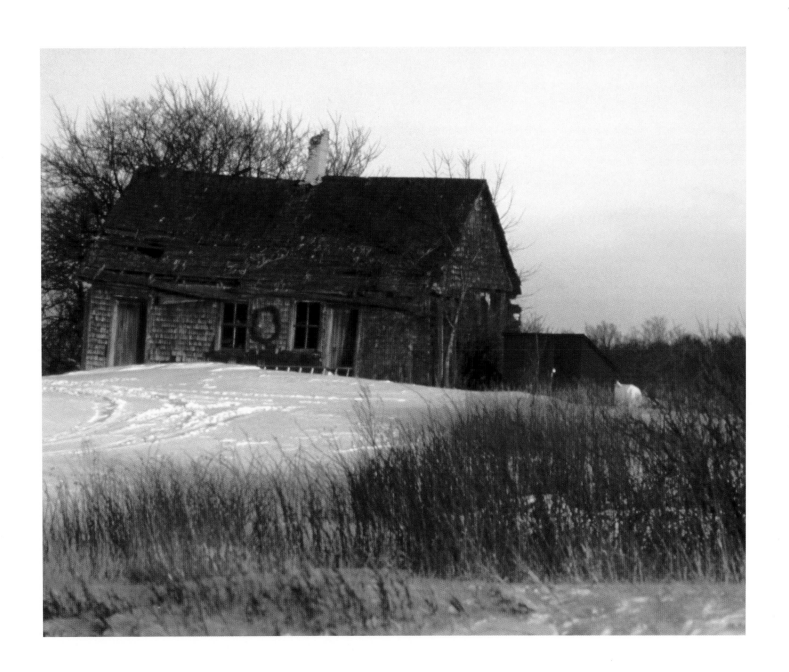

59. Emotional Remnant

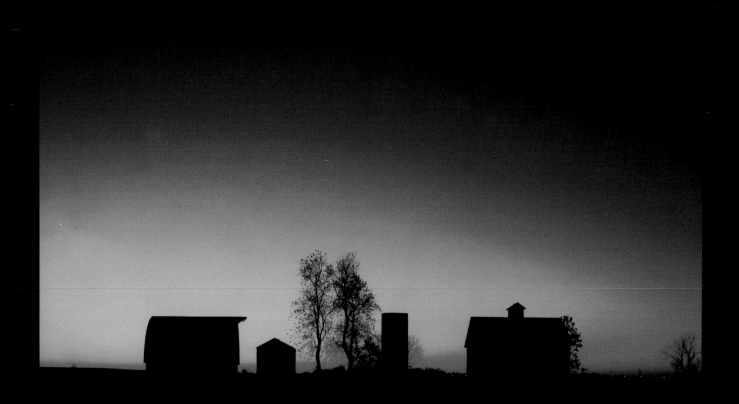

60. Fourth Season

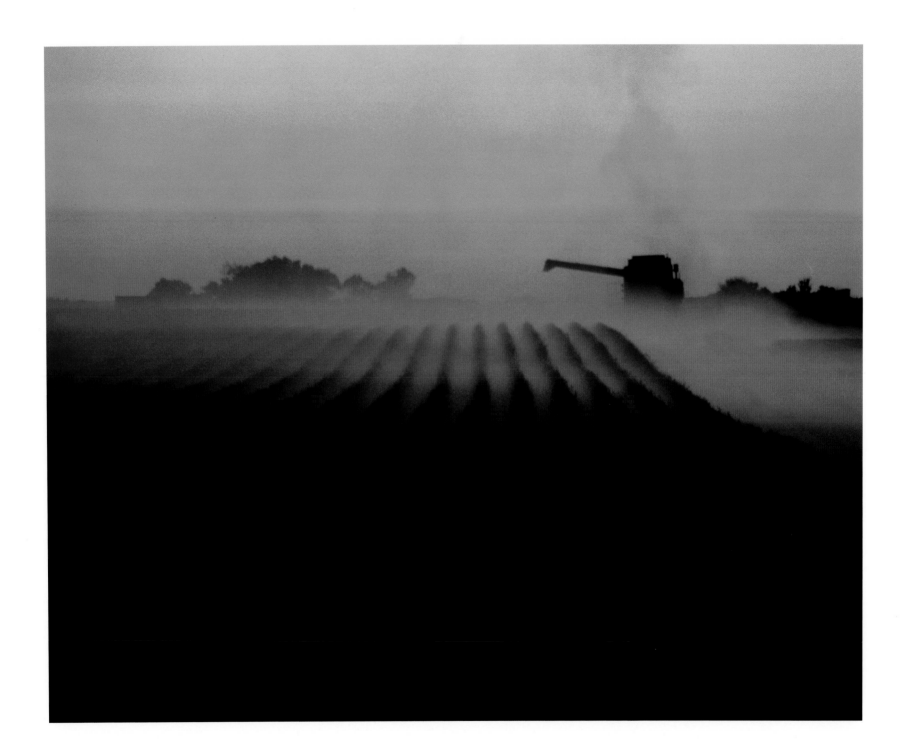

61. Apparition

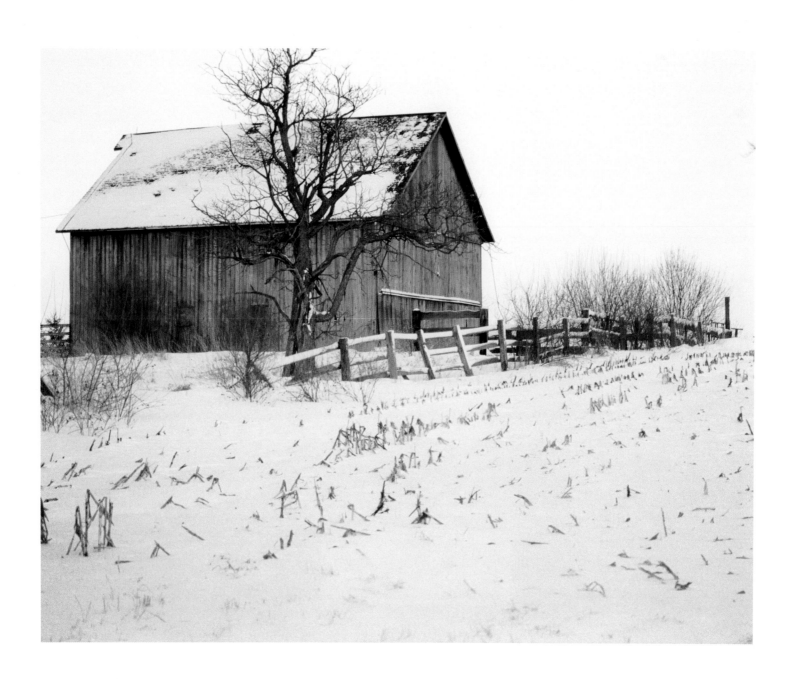

62. Winterland

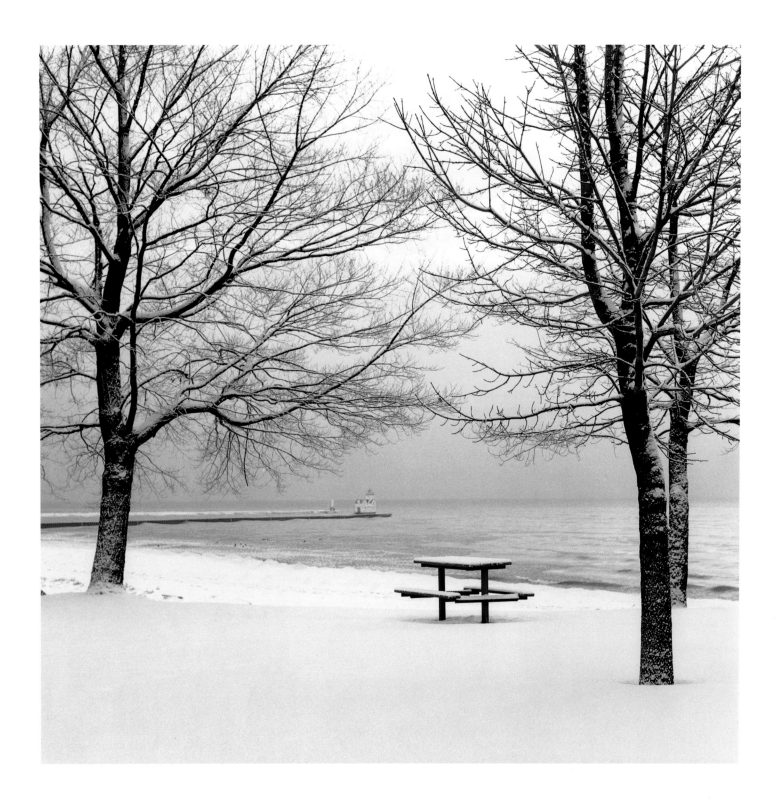

63. Summer's Past

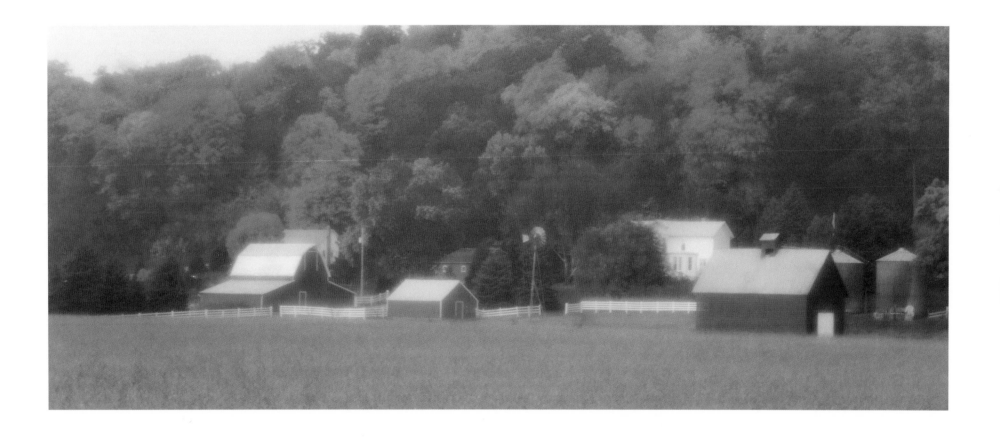

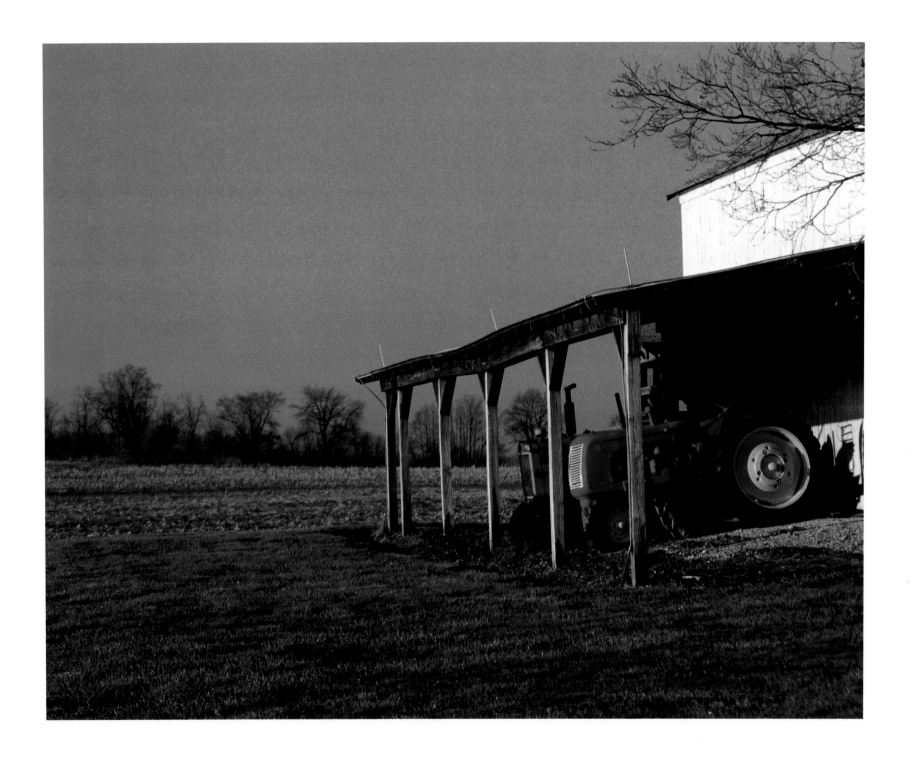

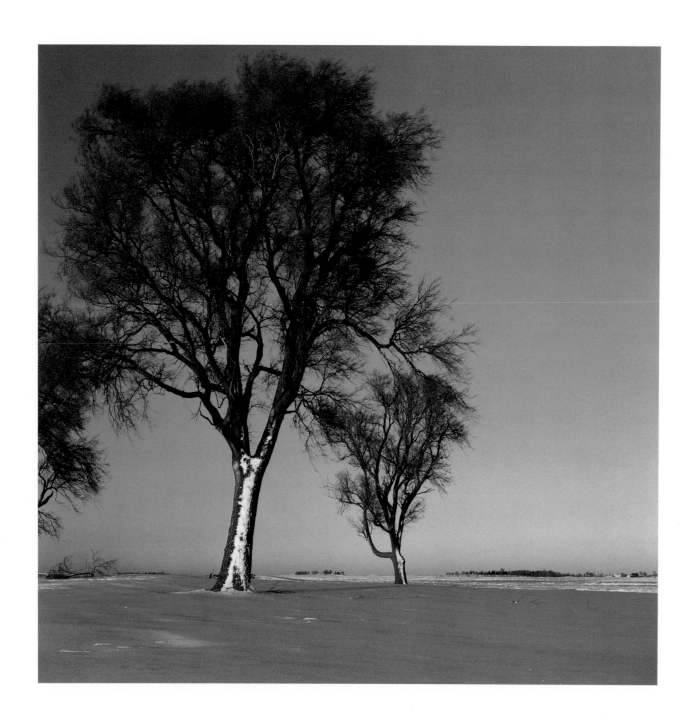

66. Siblings

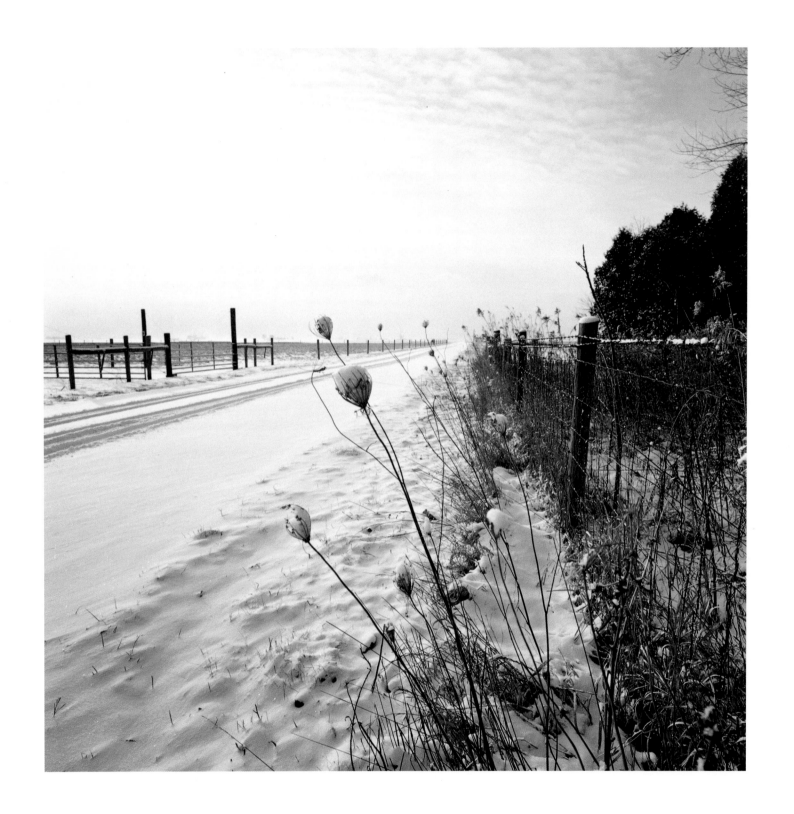

67. The Road Ahead

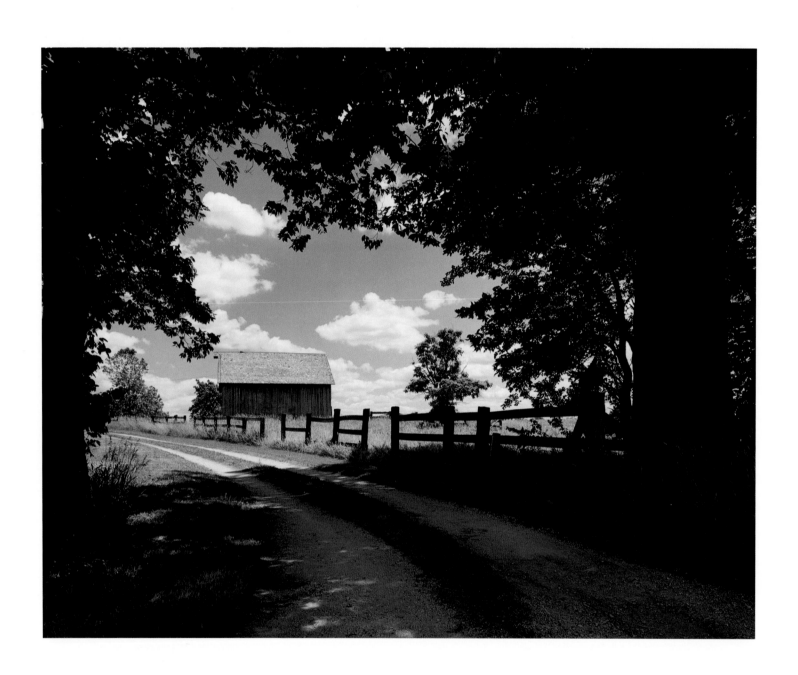

68. Heart's Hidden Place

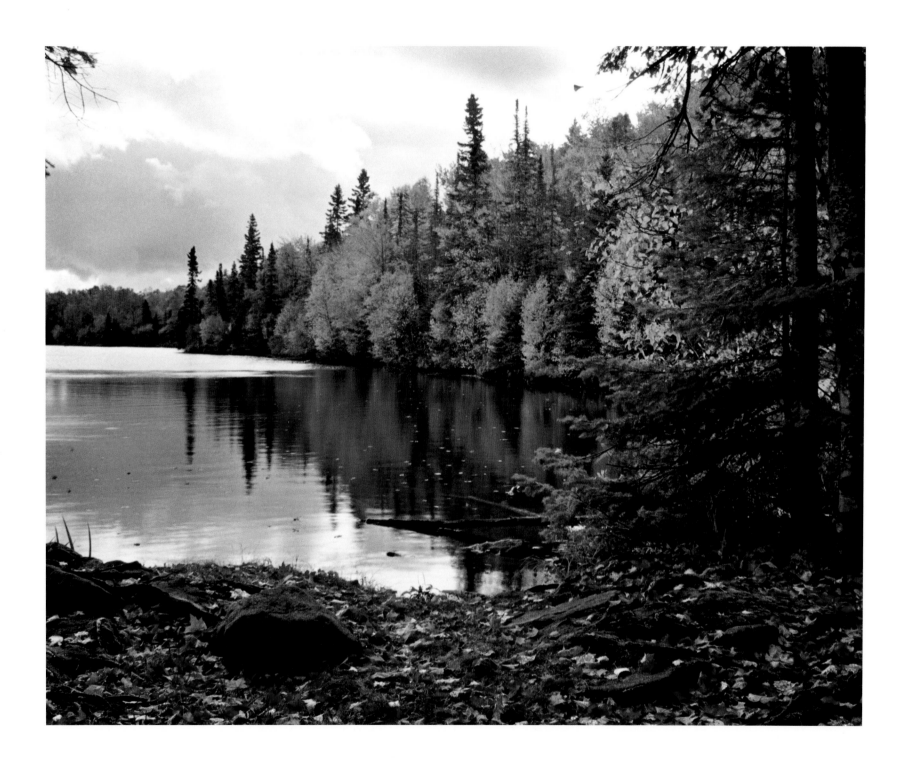

69. Northwoods Equinox

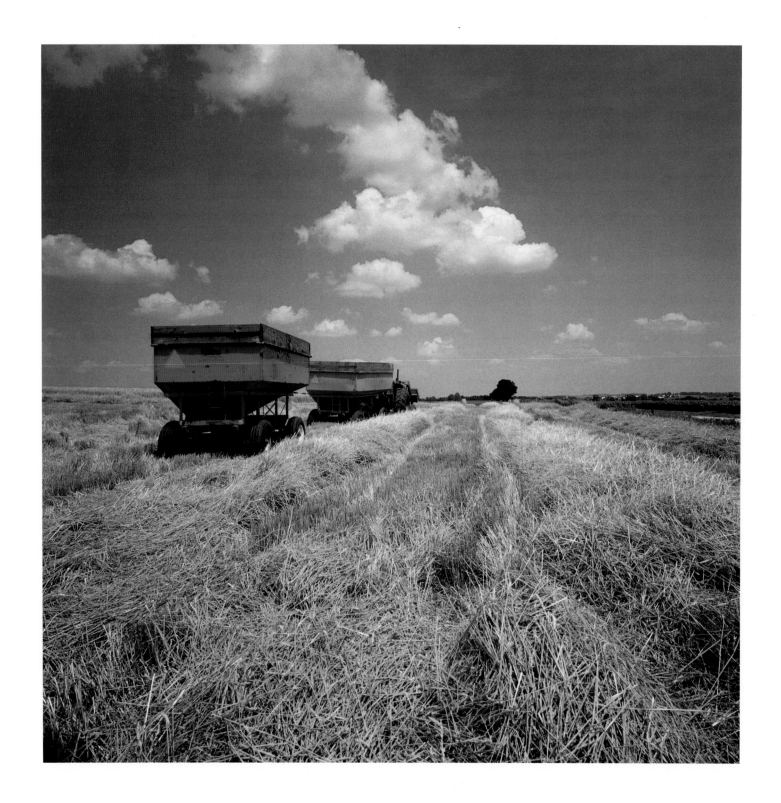

70. Convergence

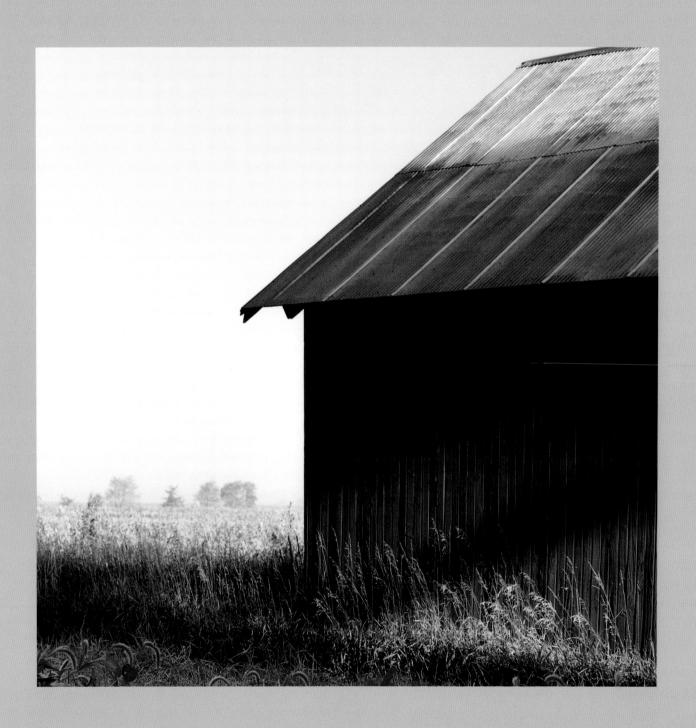

71. Resident Stranger

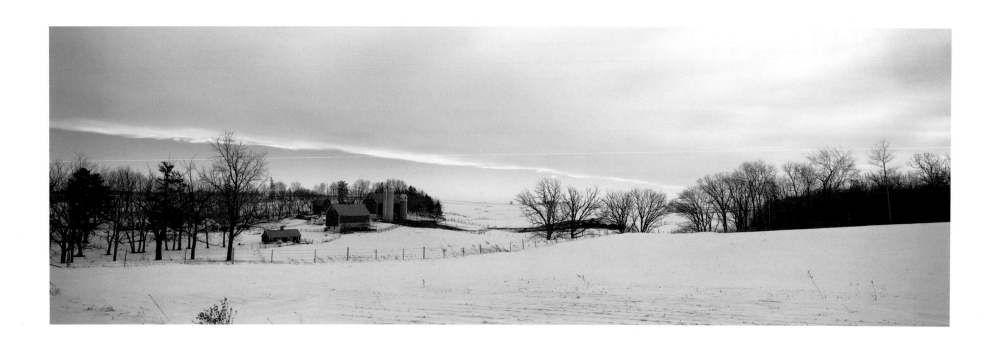

72. Midwinter Night's Dream

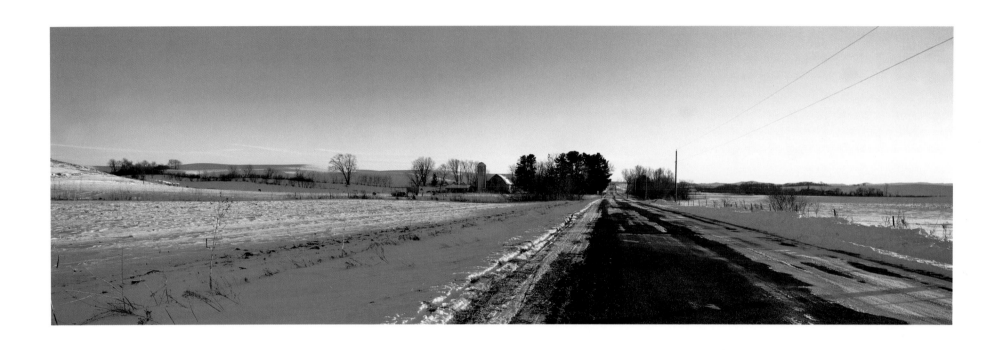

73. Untouched Dawn

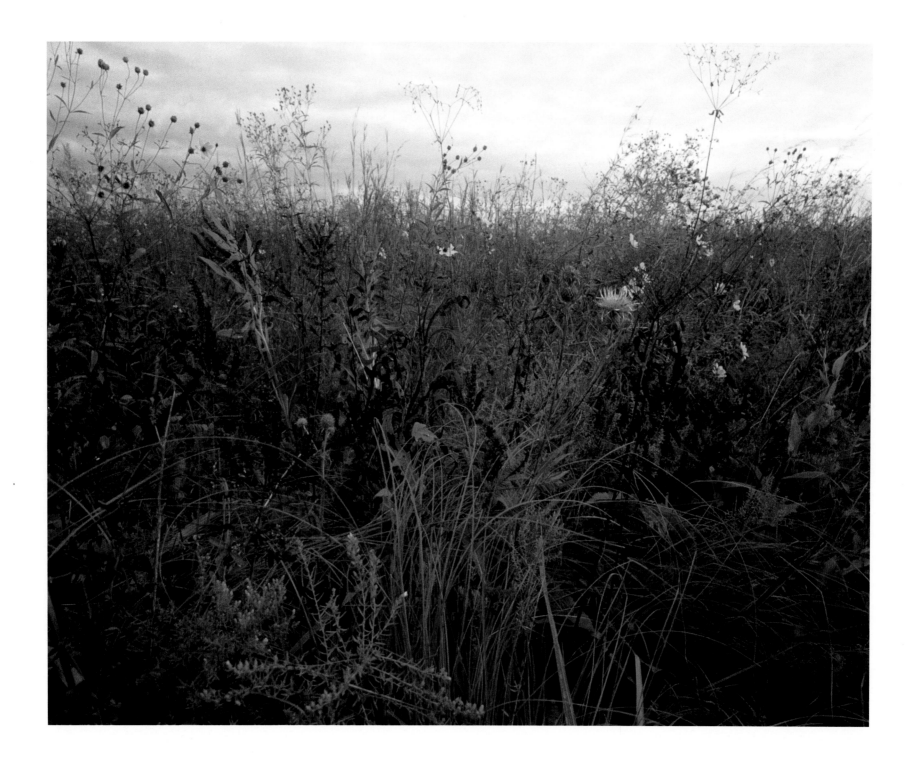

74. Prairie I

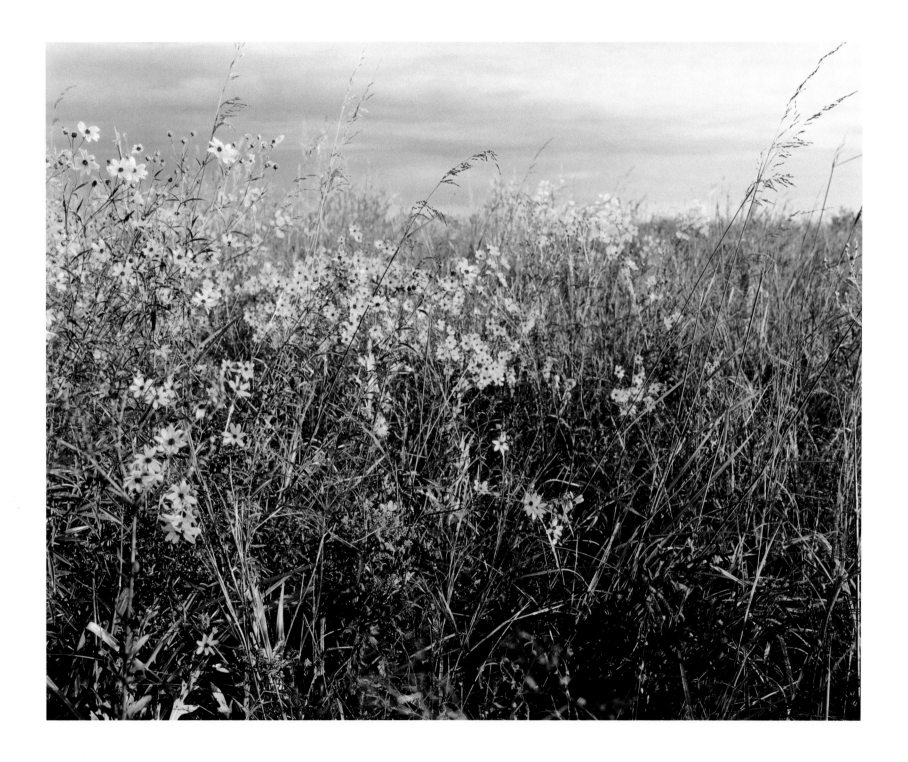

75. Prairie II

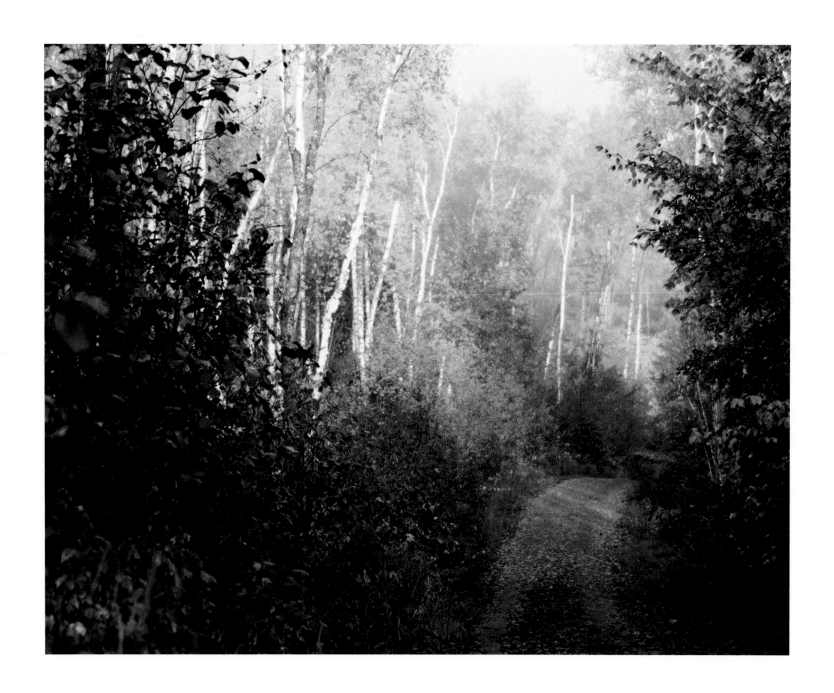

76. The Road Less Traveled

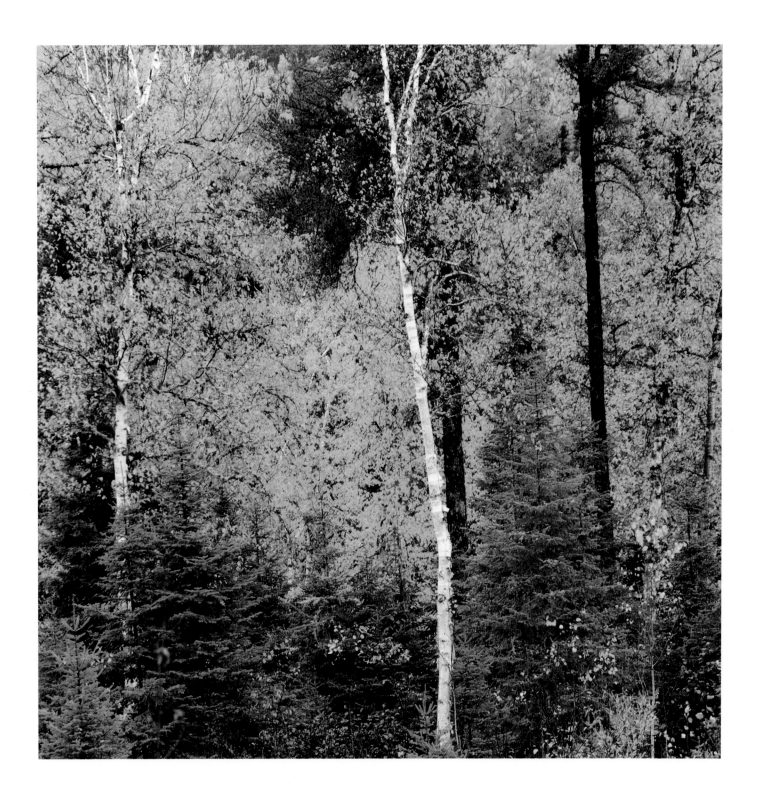

77. Aspen Textures

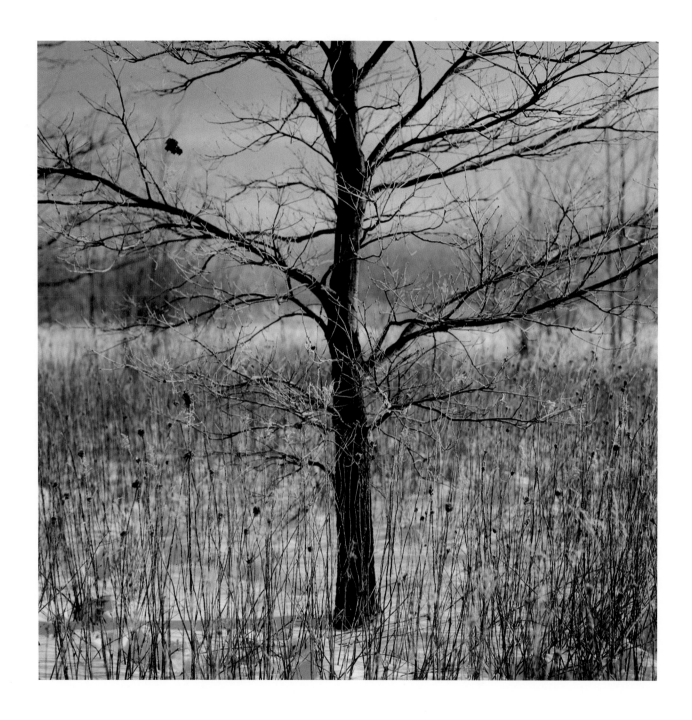

78. Standing Tall

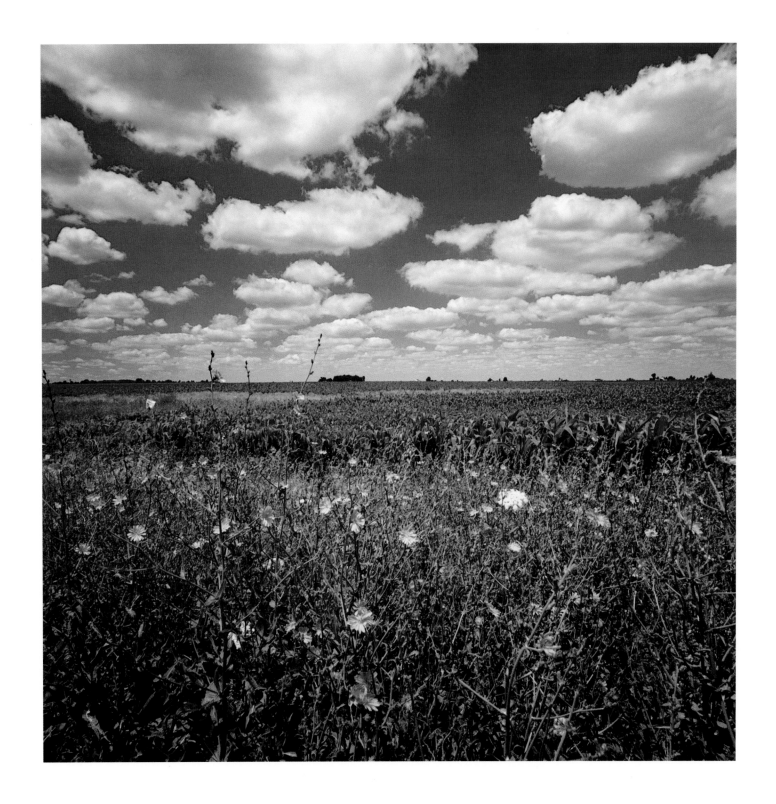

79. Fragile Flowers

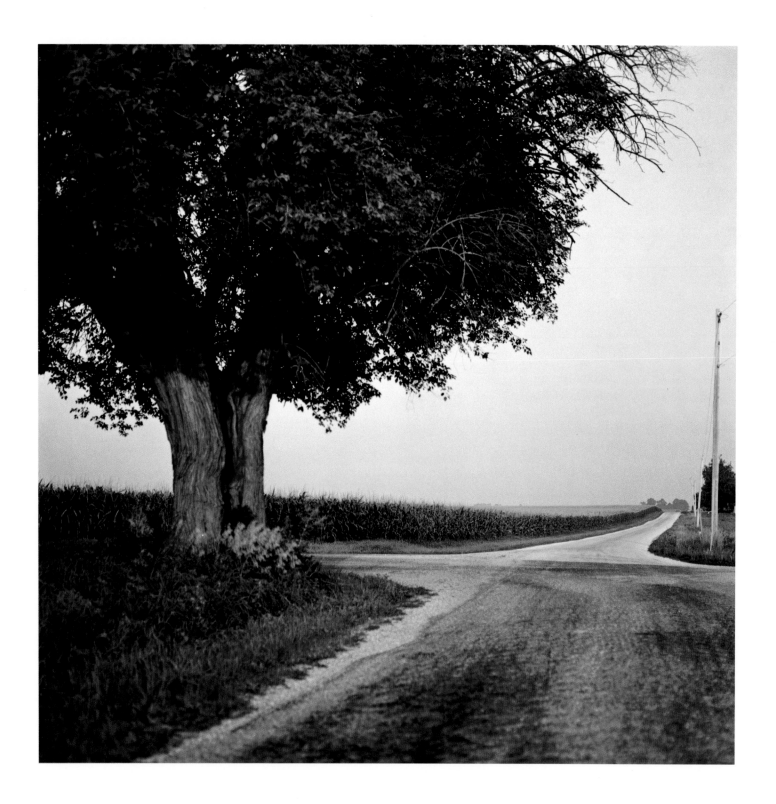

80. Legendary Crossing

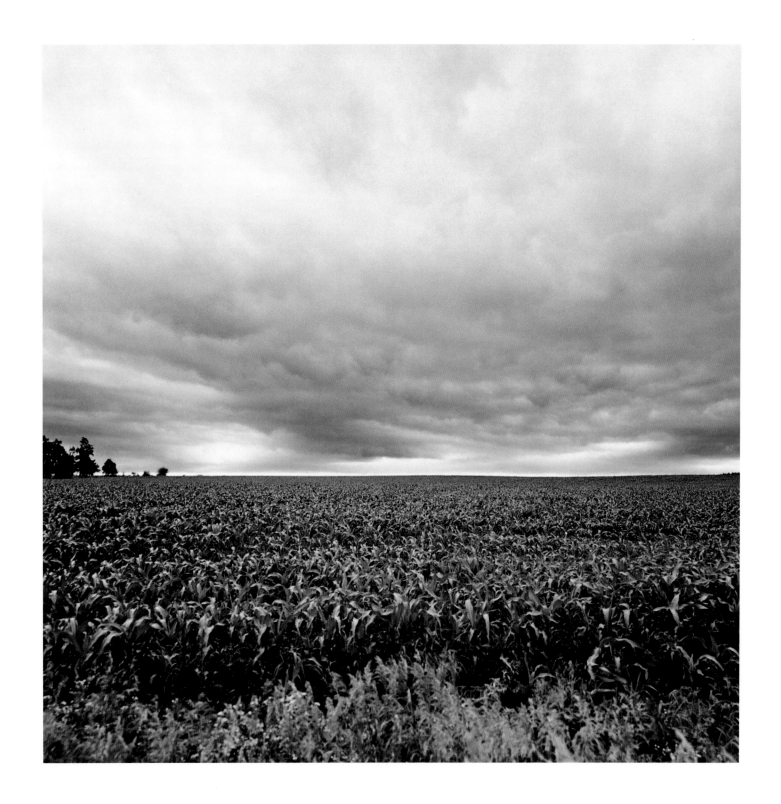

81. Between the Cracks

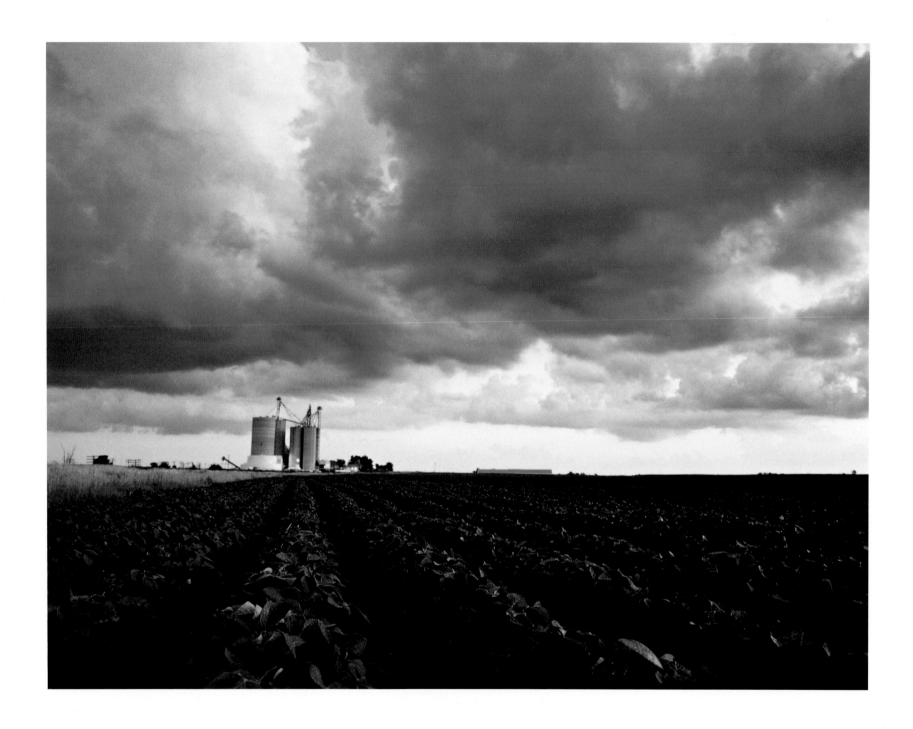

82. Tall Ships

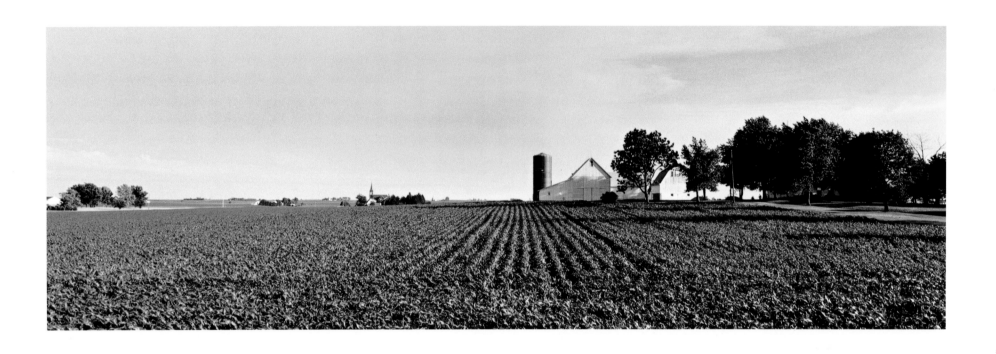

83. Country Communities

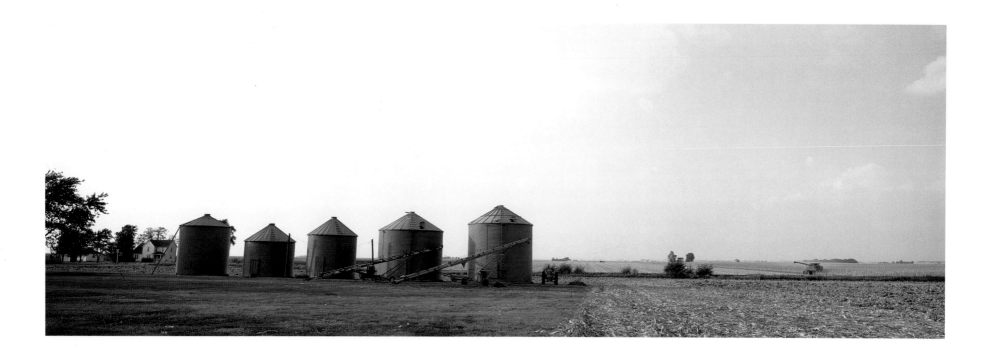

84. Five Points

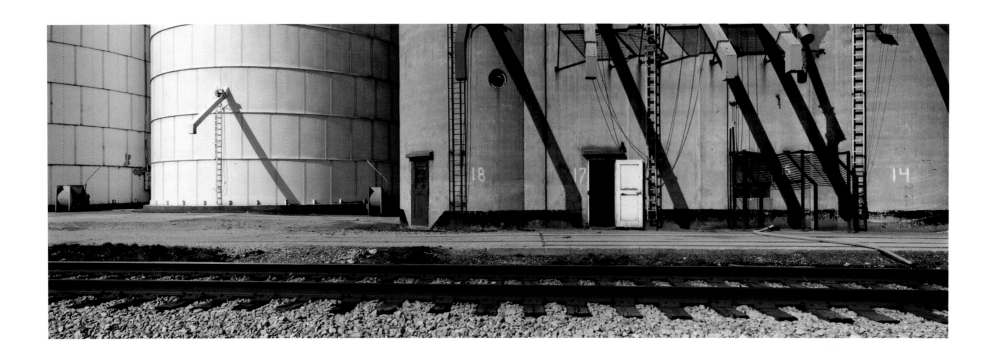

85. Harvest Station

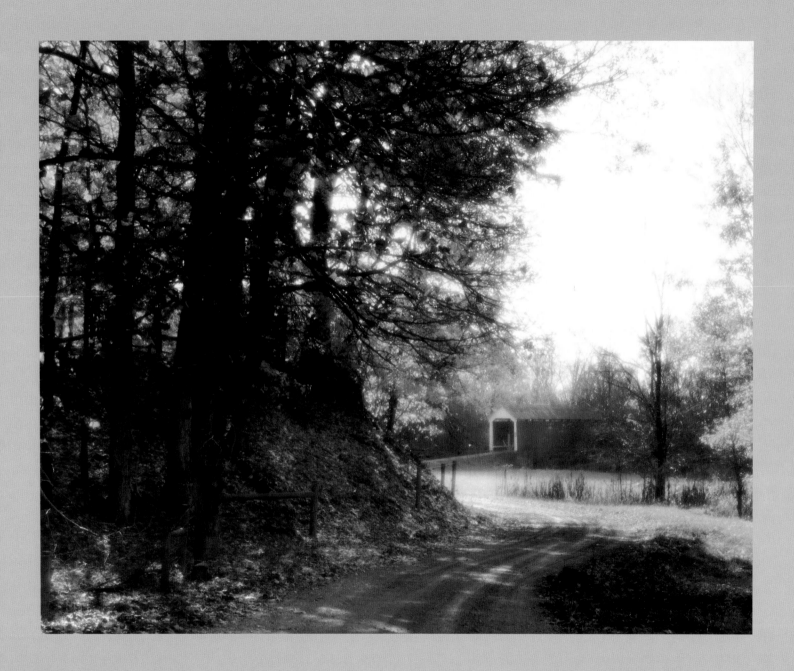

86. American Icon

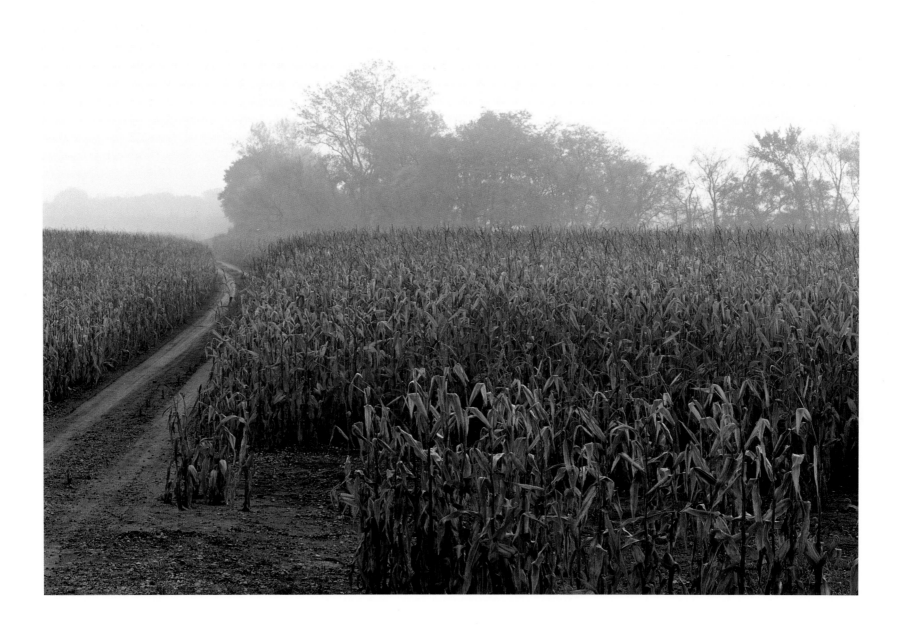

87. Miles from Nowhere

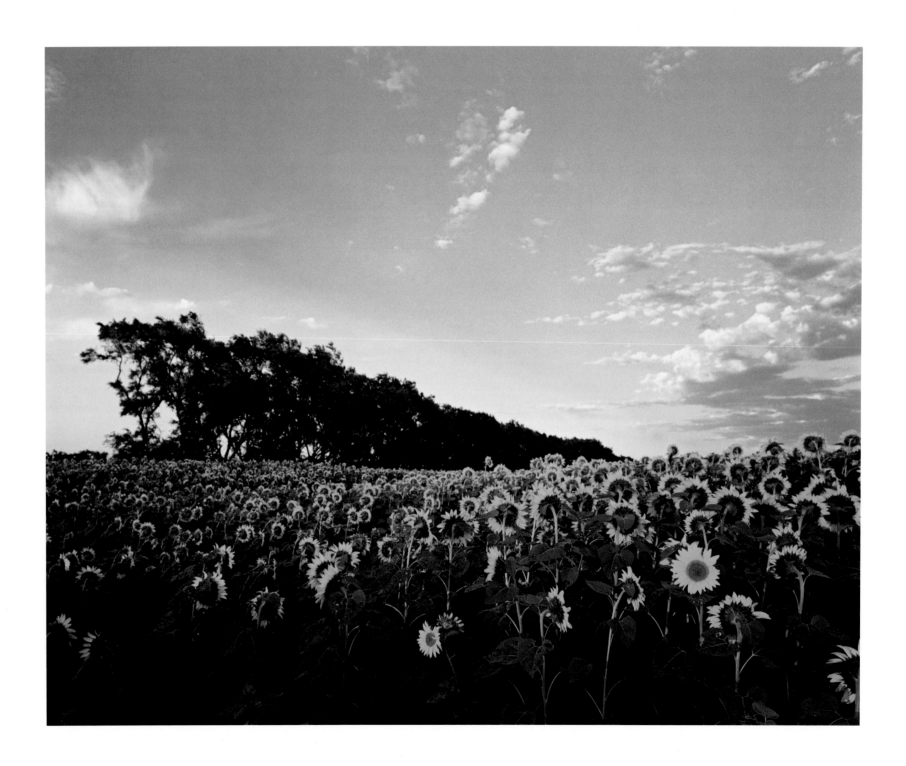

88. A Face in the Crowd

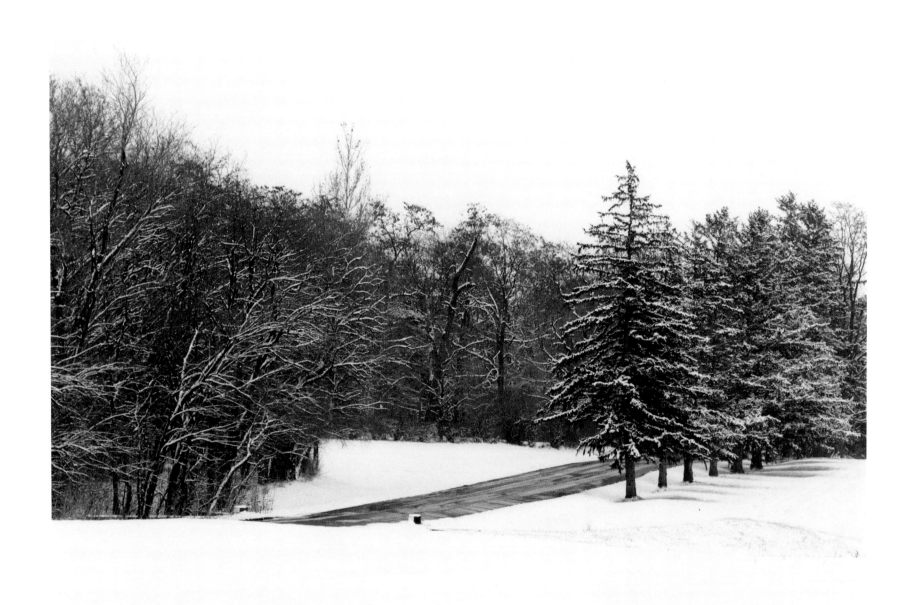

89. Sleigh Ride

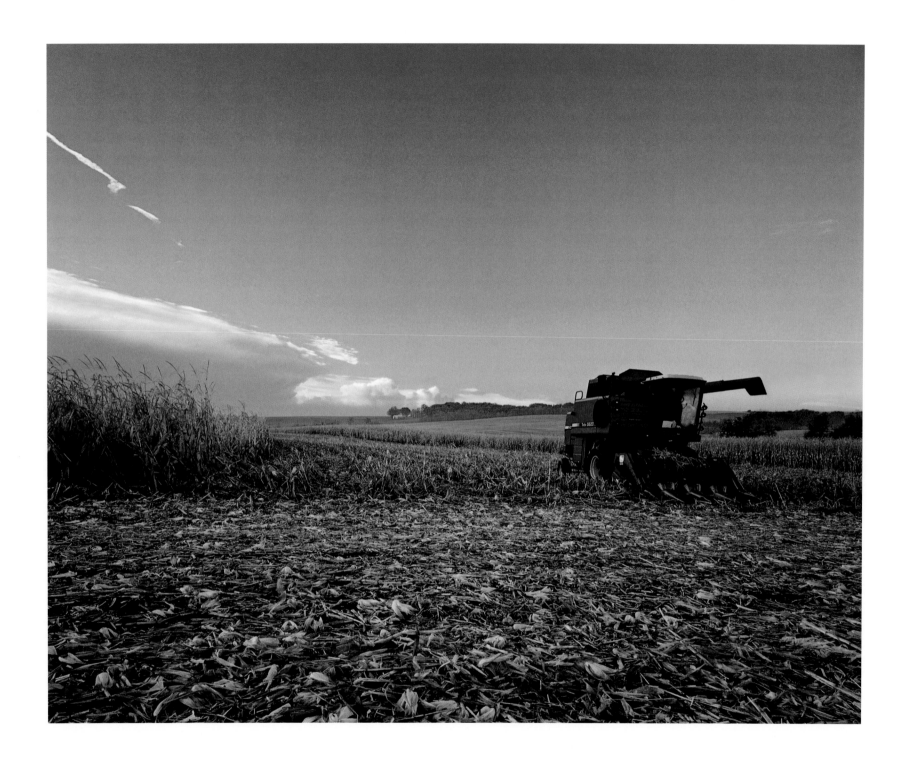

90. Work Ethic

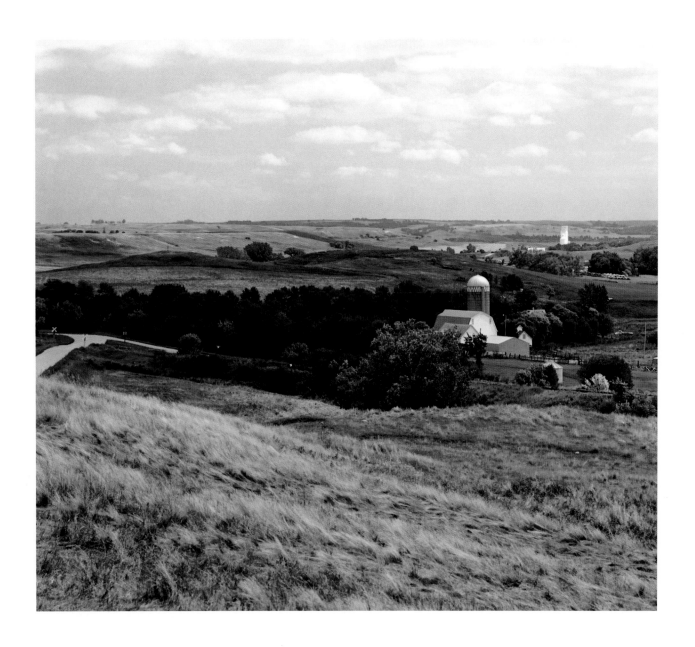

91. Painter's Paradise

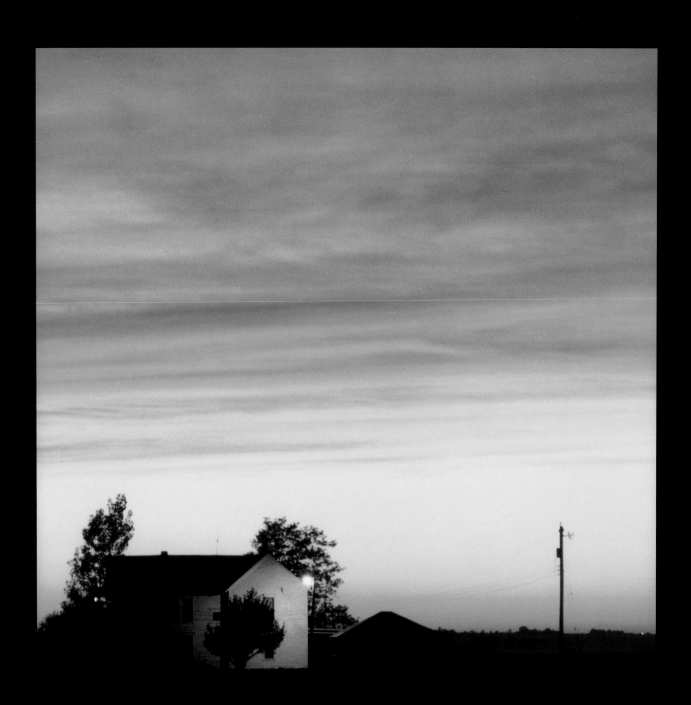

92. Prairie Fire

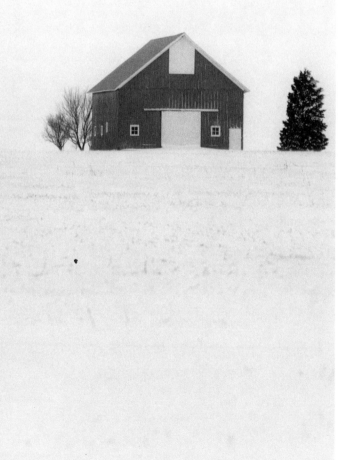

93. Heart of Winter

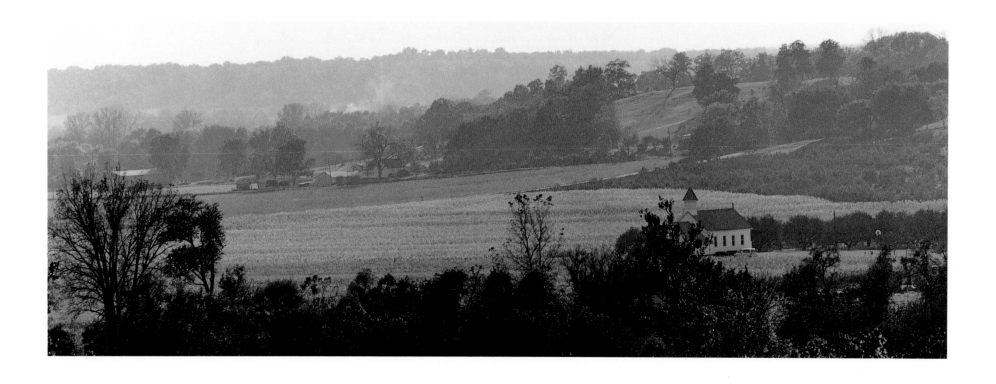

94. In the Valley

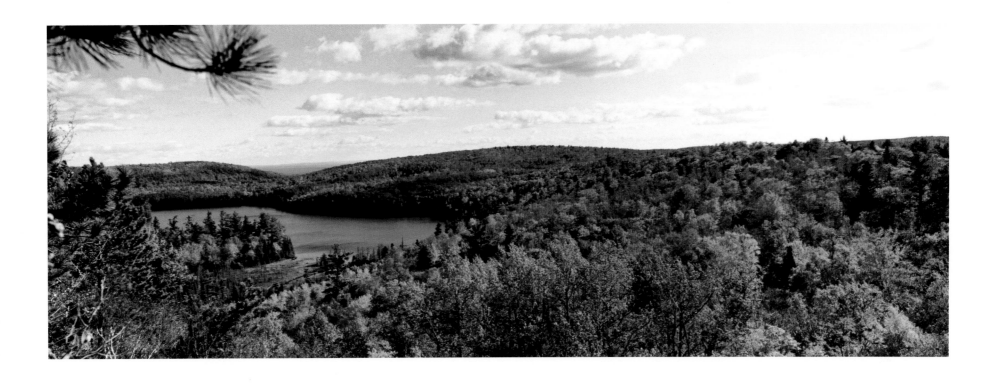

95. Autumn Exhibition

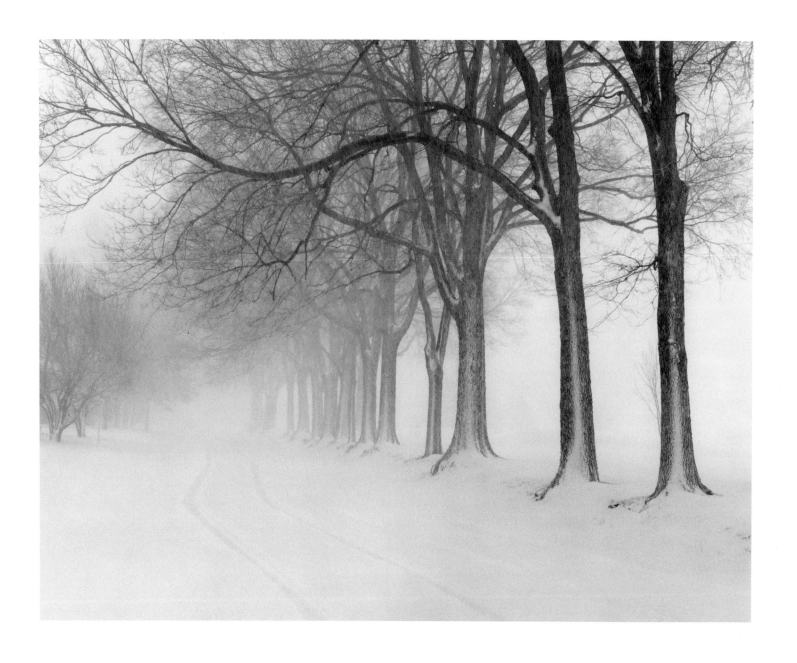

96. Promises to Keep

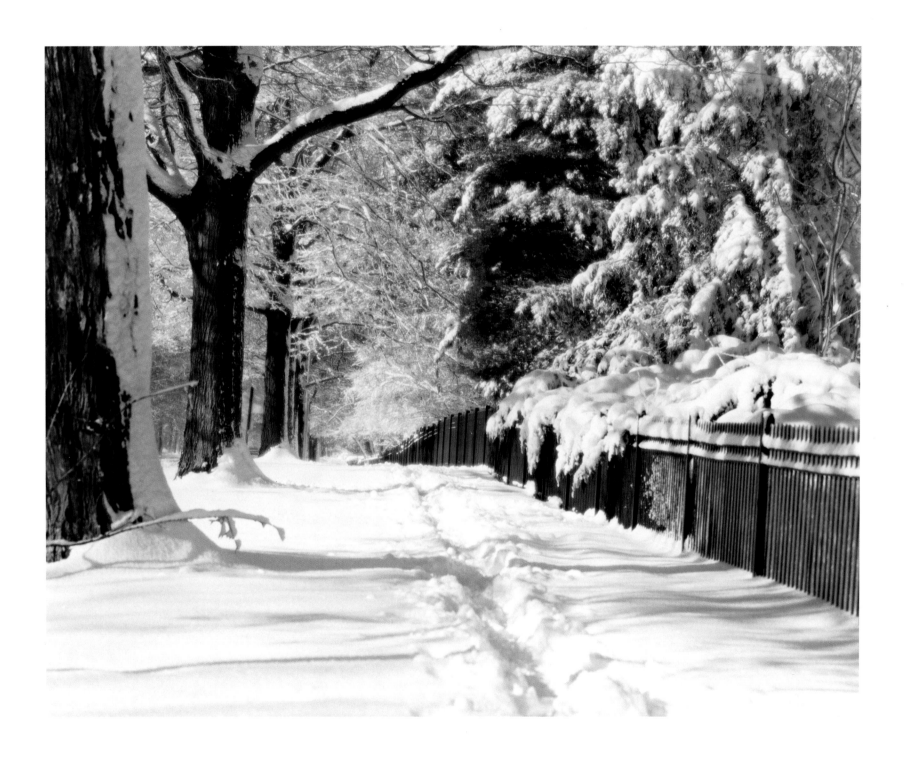

97. University and Prospect Winter

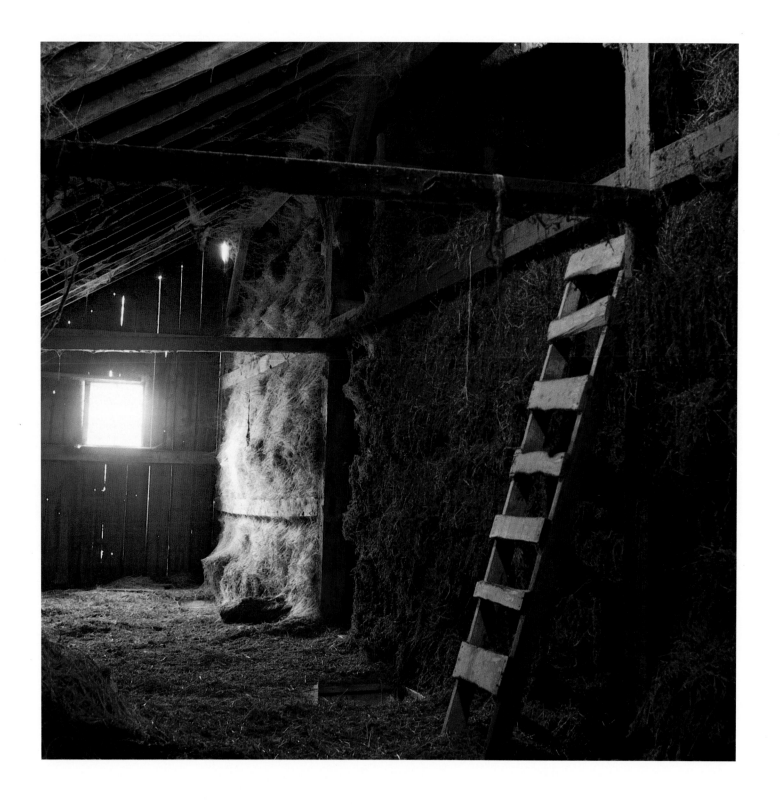

98. Hayloft

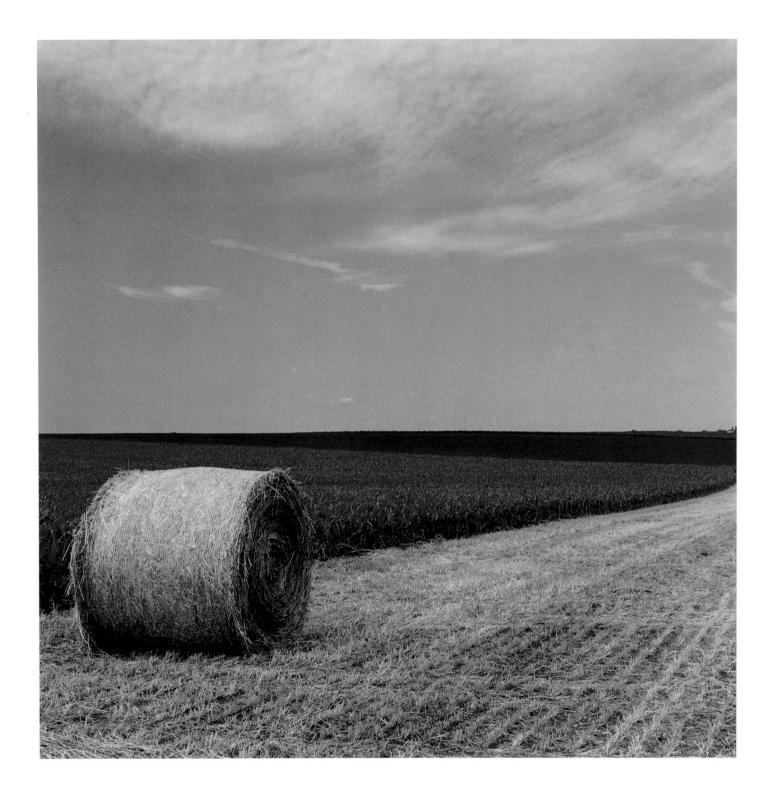

99. Midwest Vignette

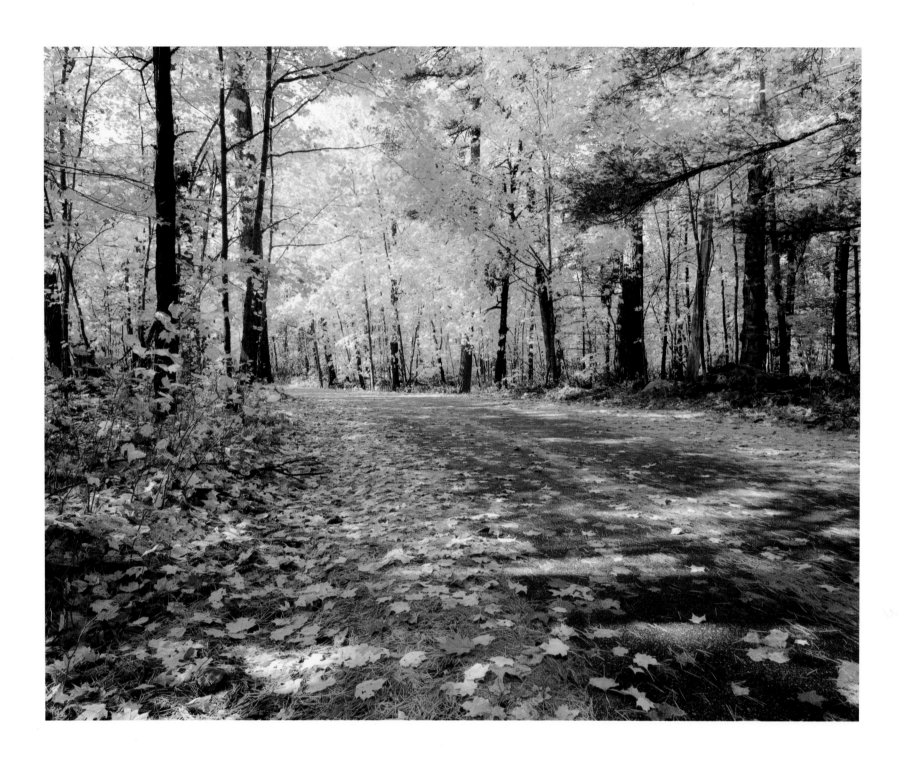

100. Lost Highway

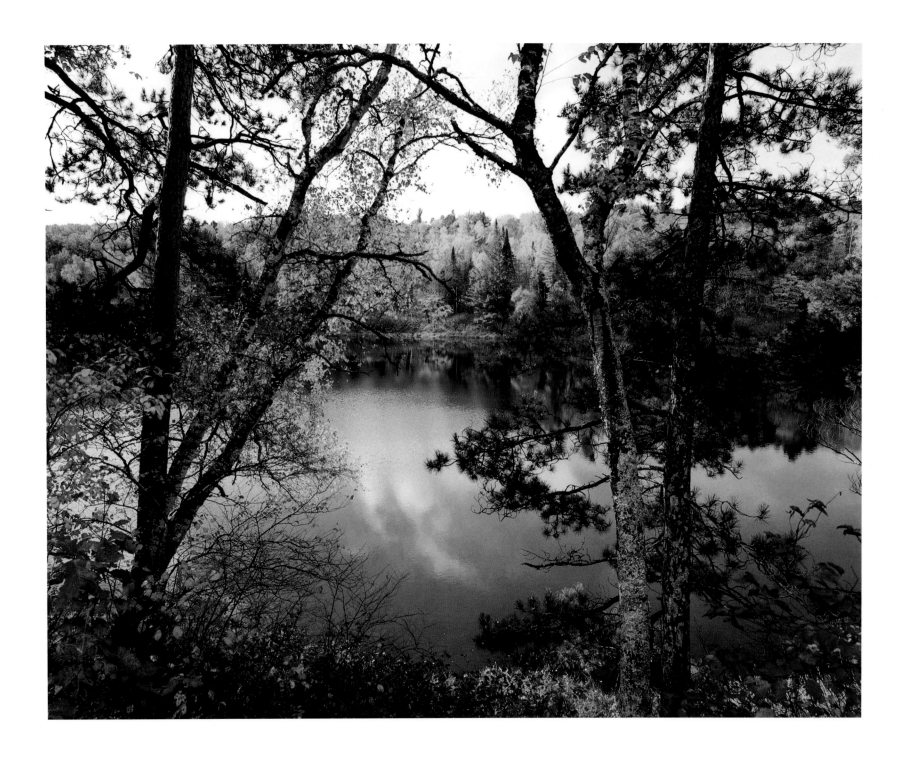

101. A Quiet Place

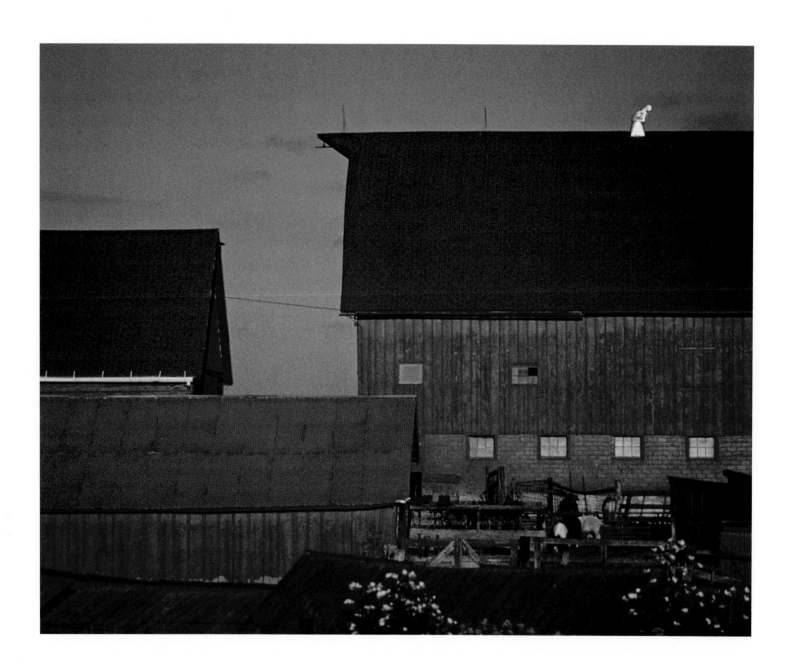

102. Endangered Species

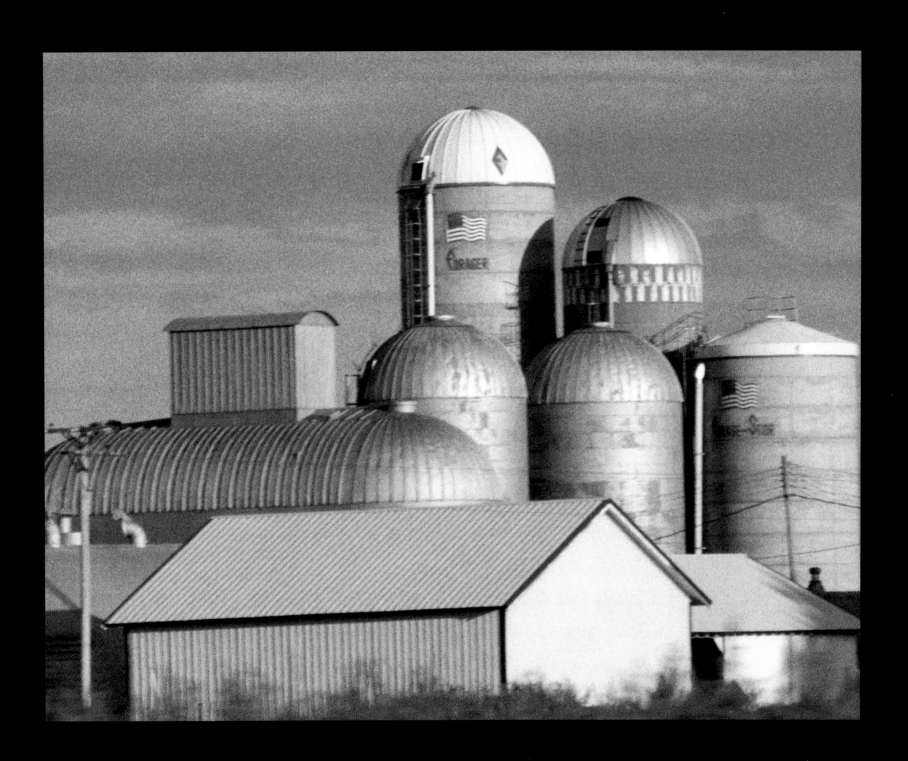

103. Shapes of Summer

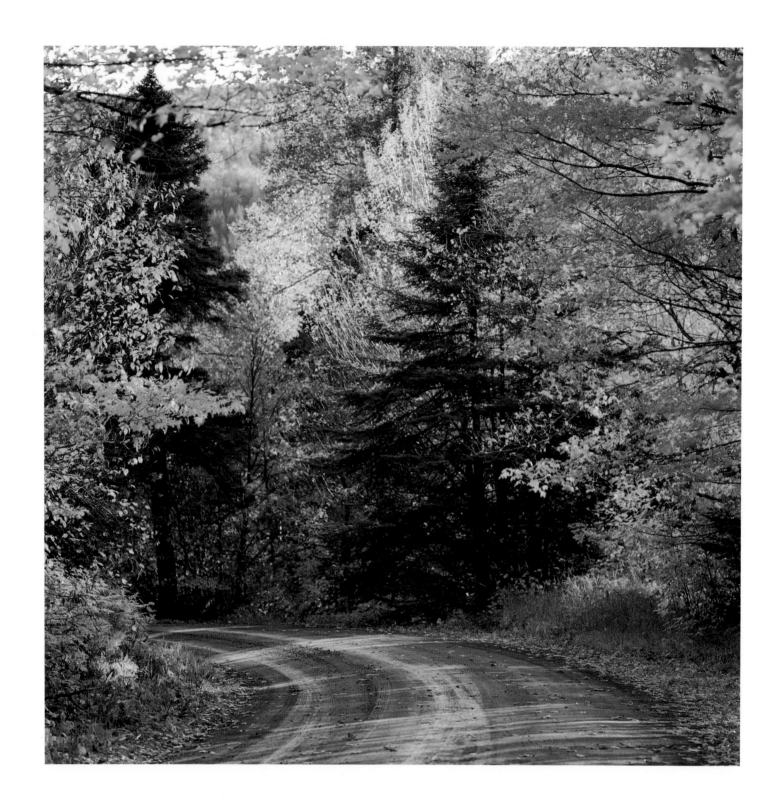

104. Heartbreak Hill

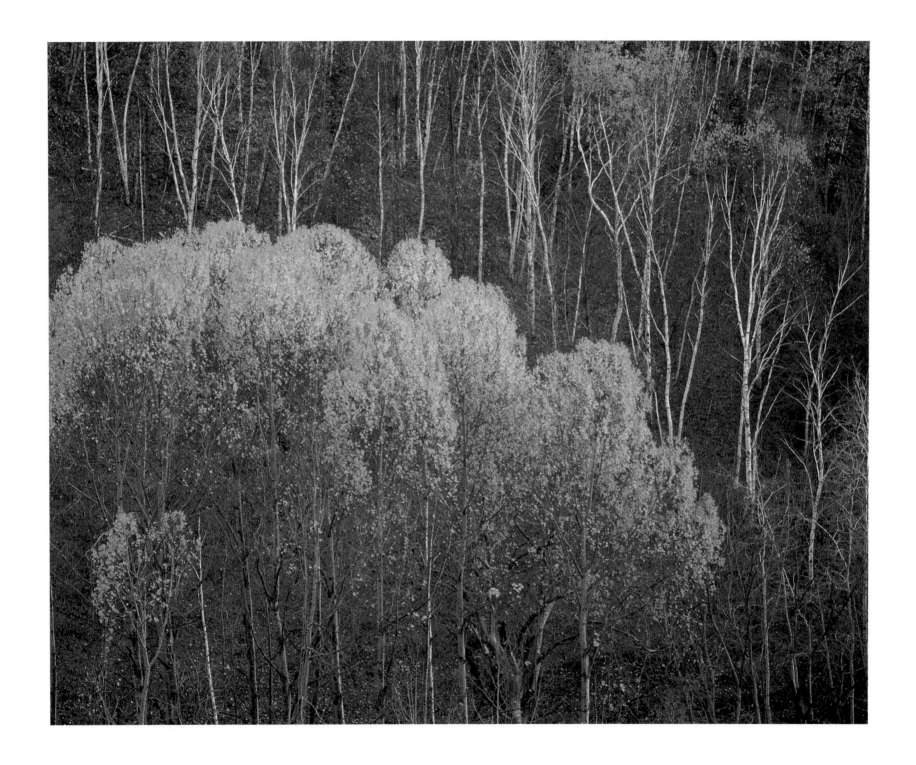

105. Golden Autumn

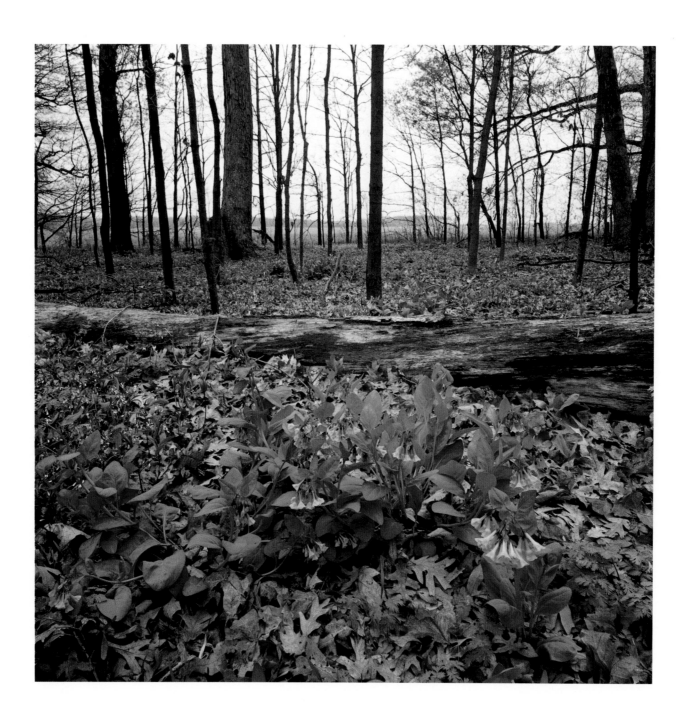

106. Anna's Garden

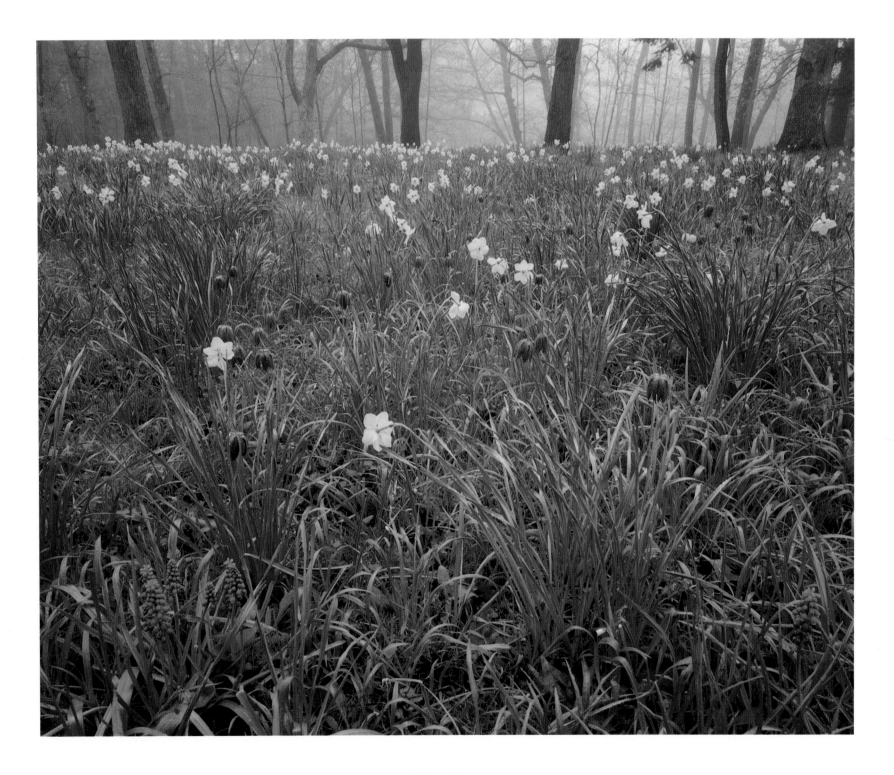

107. May Tapestry

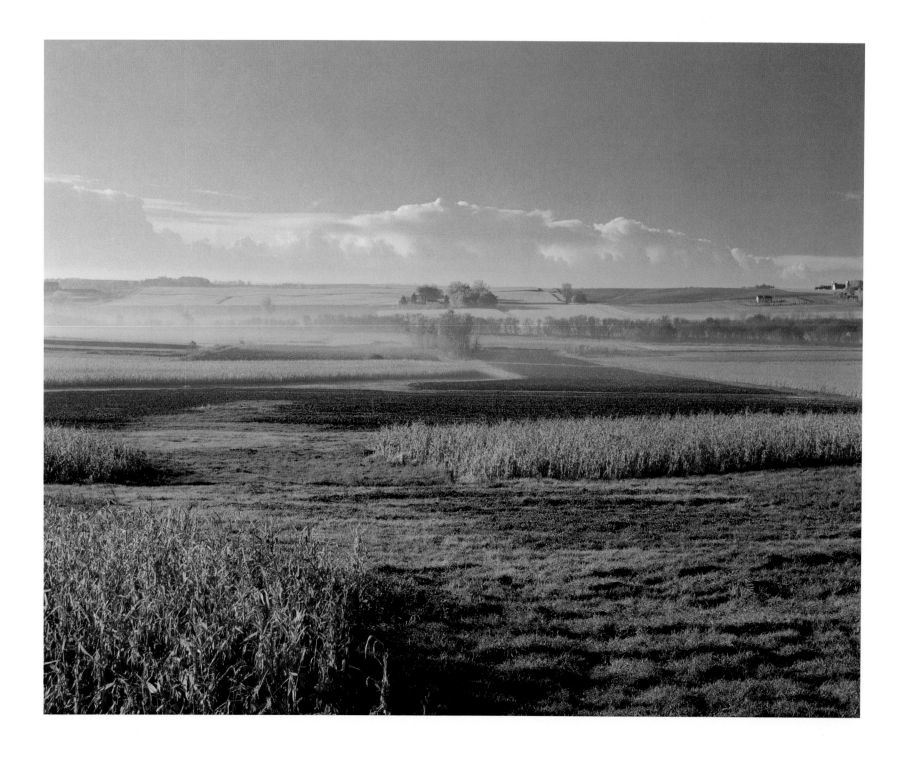

108. Early to Rise

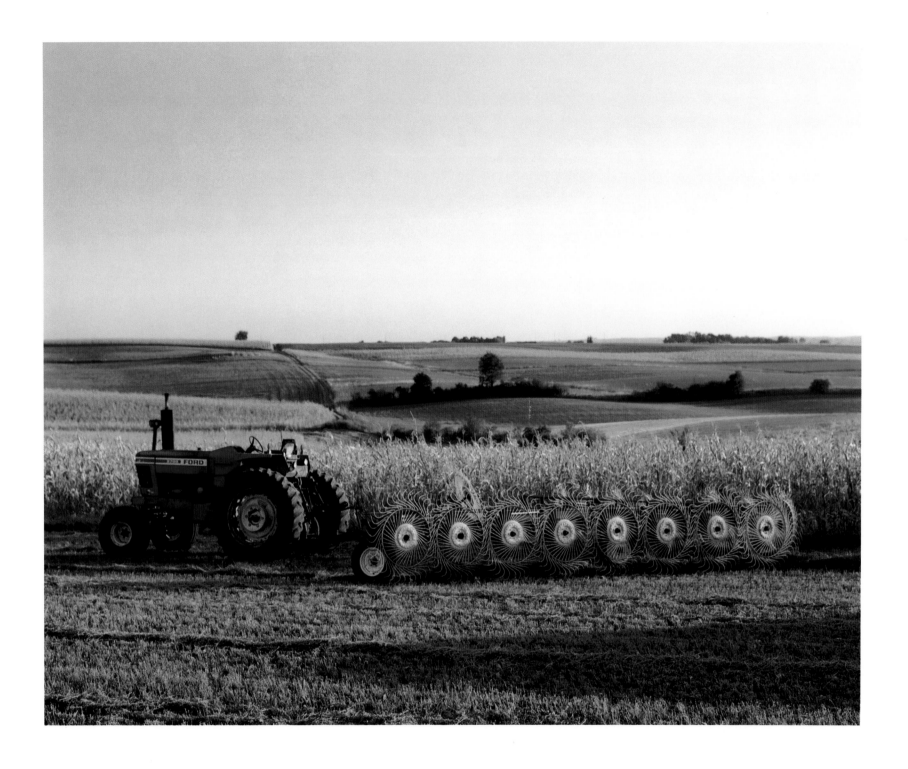

109. Rural Abstract

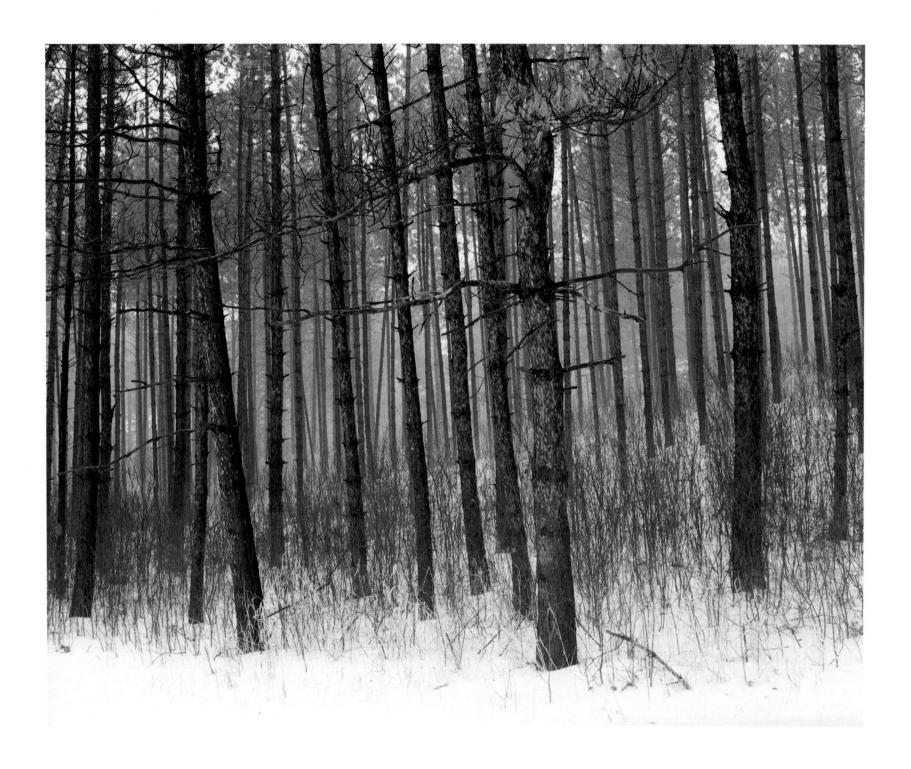

110. McGinty Woods

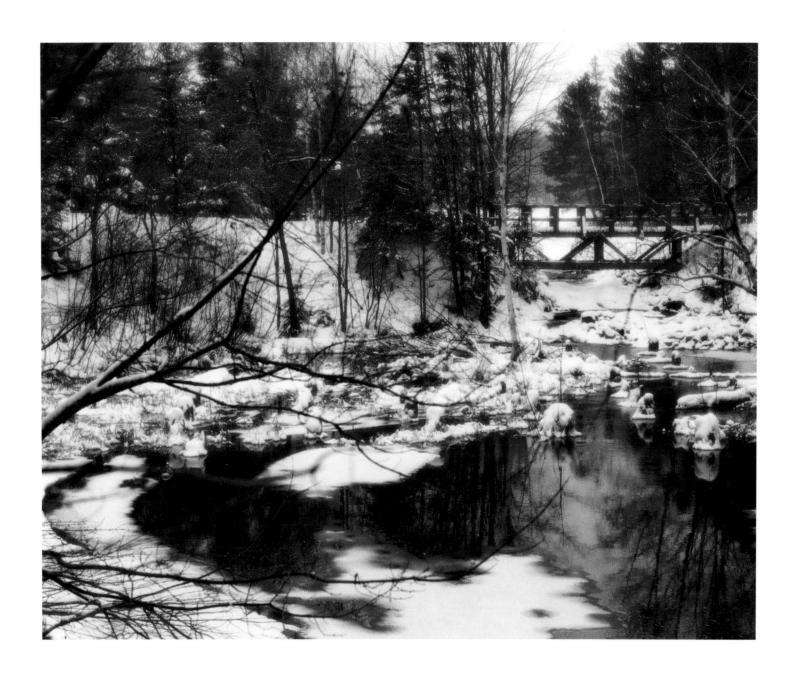

III. Over the River

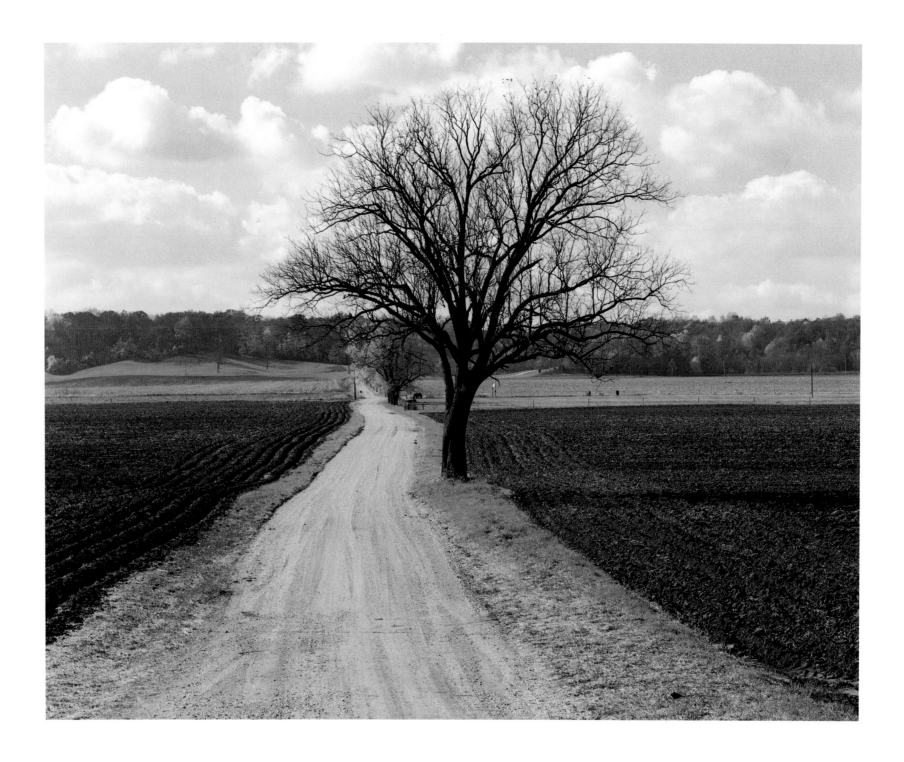

112. Witness

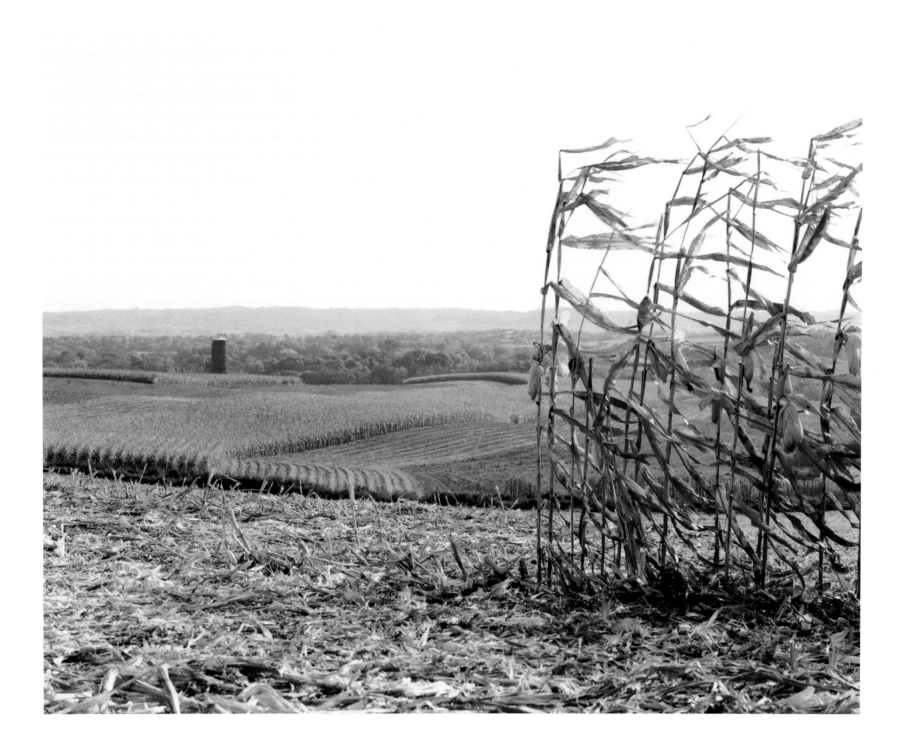

113. Loyal Citizens

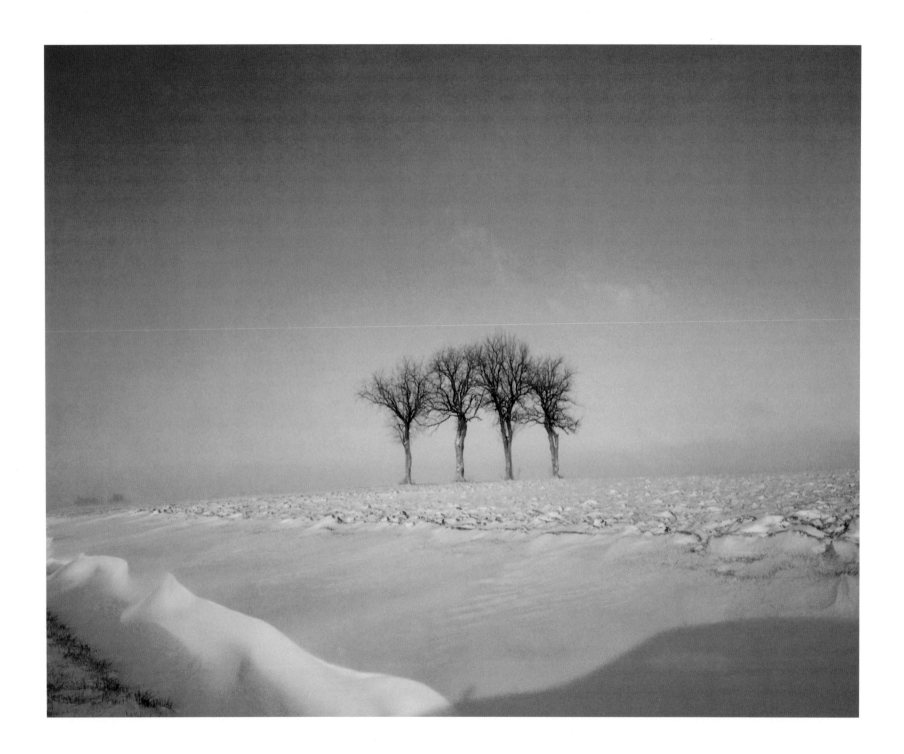

114. Frozen in Time

Born in St. Louis, Missouri, but reared in the Pacific Northwest, Larry Kanfer has spent much of his life studying and capturing on film the subtle beauty of the American Midwest. A graduate of the University of Illinois at Urbana-Champaign with a degree in architecture, he opened his first photography gallery and studio in 1980. Currently, he maintains galleries in Champaign, Illinois, and Minneapolis, Minnesota, as well as online at <http://www.kanfer.com>. His photographs have received numerous awards of excellence and are featured in corporate and private collections nationally. His other publications include *Prairiescapes* (1987), *On This Island: Photographs of Long Island* (1990), *On Second Glance: Midwest Photographs* (1992), and *Postcards from the Prairie: Photographic Memories from the University of Illinois* (1996).

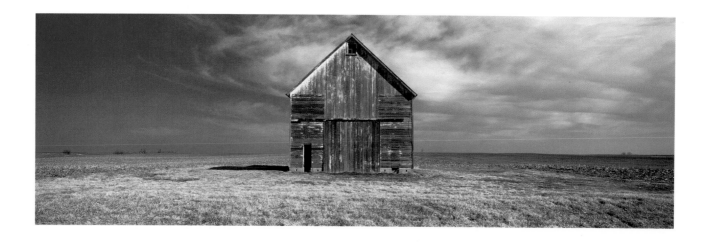

Typeset in 12/18 Gill Sans Light with Copperplate Gothic display
Designed by Copenhaver Cumpston
Composed by Jim Proefrock at the University of Illinois Press
Printed in China by Everbest Printing Company through
Four Colour Imports, Louisville, Kentucky

University of Illinois Press
1325 South Oak Street Champaign, IL 61820-6903
www.press.uillinois.edu

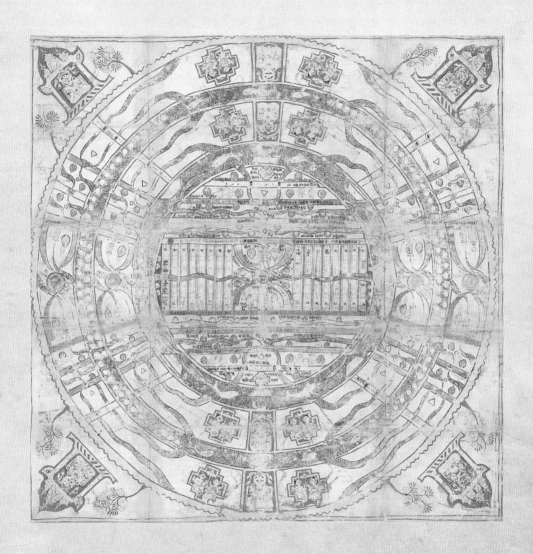

Author Acknowledgments

Swami Venkatesananda, my guru, was a living embodiment of the teachings of the Upanishads. I thank him for his presence, which made this work possible at all.

I thank brahmacharini Manisha Wilmette Brown for her conscientious editing, which is always done with love and understanding of the teachings, awareness of how their hidden truths lie in the detail, and a commitment to achieving transparency in the translation.

I thank Swami Krishnananda, whose teachings on the Upanishads are so insightful and penetrating that they transformed my vision and continue to guide my learning.

VIKING STUDIO
Published by the Penguin Group
Penguin Putnam Inc., 375 Hudson Street, New York, New York 10014, U.S.A.
Penguin Books Ltd, 27 Wrights Lane, London W8 5TZ, England
Penguin Books Australia Ltd, Ringwood, Victoria, Australia
Penguin Books Canada Ltd, 10 Alcorn Avenue, Toronto, Ontario, Canada M4V 3B2
Penguin Books (N.Z.) Ltd, 182–190 Wairau Road, Auckland 10, New Zealand

Penguin Books Ltd, Registered Offices: Harmondsworth, Middlesex, England

First American edition published in 2001 by Viking Studio, a member of Penguin Putnam Inc.

10 9 8 7 6 5 4 3 2 1

CIP data available
ISBN 0–670–89230–0

Printed in Singapore
Set in Baker Signet
Designed by Becky Clarke

Katha Upanishad

TRANSLATED BY

SWAMI AMBIKANANDA SARASWATI

ILLUSTRATED WITH INDIAN MINIATURES FROM
THE VICTORIA AND ALBERT MUSEUM, LONDON

VIKING STUDIO

dedicated to

my guru Sri Swami Venkatesananda Saraswati

and Sri Swami Krishnananda Saraswati

both of Sivananda Ashram, Rishikesh

CONTENTS

Introduction: A Dialogue with Death

Is death the end? This question, which plagues us all, is the mystery at the centre of the *Katha Upanishad*. When Nachiketas is sent by his father to the realm of death, he is confronted by Yama, the formidable God of Death. Having kept the young brahmin waiting, Yama is forced to grant him three wishes. As his third and most important wish, Nachiketas asks:

> *There is much confusion about death:*
> *Some say we continue to exist*
> *After the body has died,*
> *Others say we do not.*
> *Tell me the truth –*
> *What happens when life leaves the body?*
>
> ('The Beginning', verse 20)

In answering the question that Nachiketas puts to him about death, Yama also answers the fundamental question about life – who am I?

The *Katha Upanishad* is part of the *Yajur Veda*, one of the four surviving Vedas, sacred texts of Hinduism. As written works, the Vedas were completed between 800 and 1000 BCE. As oral works, they go back before recorded history. Originally many in number, the Vedas were outpourings of the spiritual knowledge of the early human family, who sought the same things we seek now: happiness, an understanding of who we are and a knowledge of the indefinable Presence that we somehow sense but seem unable to experience directly. The Vedas were written in Sanskrit, the ancient language of India and the language of the *Sanatana Dharma*, the 'Eternal Law' or 'Eternal Pathway'. This is the name by which Hindus refer to their religion but it can also be interpreted, with a more universal meaning, as the pathway by which we may all come to know ourselves.

The Upanishads are also called *Vedanta* because they come at the end of the Vedas and contain the essence of their teachings. The word 'Upanishad' gives an idea of the richness of meaning contained in these texts. It means 'to sit close', implying the teaching received when one draws close to the teacher. Equally, it can be taken to mean the inner essence of the teaching, which we receive when we 'go close' to the teaching itself. Traditionally, it was only when the student had been with the teacher for some time and was showing the right aptitude and readiness that the teachings contained in the Upanishads were imparted. The Upanishads were known as *shriti*,

meaning 'that which was heard', or oral teachings. All oral traditions seem to call upon the listener to engage in an understanding that is beyond the limitations of the intellect, to enter an inner state of knowing, an awareness outside of our ordinary analysis of the world. Thus it may be that Upanishad is what we hear when we sit close to our own stillness and listen. However one chooses to interpret the word, the ancient wisdom is that the Upanishads contain self-evident truths to be discovered in whatever time and place one asks the questions they pose.

If we read the *Katha Upanishad* as a quaint story about a man who got angry with his son and said 'Go to hell!', it will entertain us. If we see ourselves reflected in its characters, it will teach us. Nachiketas' father, Vajashrava, is the part of ourselves that tries to forestall death by engaging with the things of the world. Nachiketas is the part of ourselves that turns to death to find an understanding of life.

In accordance with the universal nature of this teaching, I have chosen not to genderize God or the spiritual practices. The gender usually adopted in translations of sacred texts is male: He, Him, the wise man. Such translations remove from women the opportunity of seeing themselves reflected either in God or the wise. Removing gender places the ultimate Reality of which Yama speaks where the text itself places it – in the heart of everyone.

This is not a translation for scholars. There are many scholarly translations of the *Katha Upanishad* and I applaud them for all that we can learn from them. This is a translation for those who like myself are seeking answers to fundamental questions. In order to reach the widest possible audience, I have chosen to maintain the tradition of my guru, Swami Venkatesananda Saraswati, and have rendered an interpretive translation.

Sanskrit, like the texts it conveys, does not reveal itself all at once. We have to draw close to it and as we do our understanding changes. In the *Katha Upanishad*, Yama offers Nachiketas three wishes. The first thing that the young boy asks for is that when he returns to the world his father will recognize and welcome him. Suddenly, we realize that this is our wish too. We see ourselves as 'here' and the rest of the world as 'out there'. At best, the world is indifferent to us and we are forced to 'make our way' in it through great effort. At worst, it is hostile and our efforts have to be increased to a level where they are overwhelming. We give names to these efforts: ambition, assertiveness, positive affirmation. Nachiketas asks that his relationship with the world be different – he wants the world to know him, to recognize him, even to embrace him. What a different world that would be: one in which it is a given that we are not isolated but welcomed as a part of it.

In the third chapter, 'The Inner Terrain', the beautiful core metaphor of the chariot must surely be one of the very first attempts at analysing the human persona. Here, Yama likens the body to a chariot, the road along which the chariot is travelling to the world, the horses to the five senses, the reins to the mind and the charioteer to a mysterious something called *buddhi*. This word *buddhi* seems to have put most translators in a quandary, perhaps because English does not have a precise equivalent. Nor do we possess the kind of analysis of the human persona that the writers of the Upanishads had. For them, we are made up of parts, which they call the *tattvas*. Some of these parts are external, like the senses, the hands and the feet, and others are internal, like the mind, the awareness and the ego. It is here that translations can become confused.

In the early and popular Hume translation of the *Katha Upanishad**, *buddhi* is translated both as 'he' and as 'intellect' – a tradition followed by most other translators. However, Hume also translates words like *atman* or *jnanam* as 'intellect'. In fact, *atman* is more usually translated as 'individual soul', or 'Self', while *jnanam* is more often 'one who knows' or 'that which knows'.

Buddhi comes from the Sanskrit root *budh*, 'to be aware'. One who is wholly awake is called a *buddha*. The *buddhi* must therefore be distinguished from the intellect and the mind as that which is aware and has the potential to become fully awakened. Before its fully awakened state, *buddhi* engages with the mind, making choices based on the mind's activity, and in that context can be called intellect. *Buddhi*'s awakened state, however, can be said to be one of choiceless awareness. For this reason, and also because it is close to the word *budh* or 'Awake!', which is used by Yama in the text, I have translated *buddhi* throughout as 'awareness'.

The *buddhi* fully awakened is aware not merely of the world and the means by which we know it, but also of another presence in the chariot, the divine Self. The Sanskrit word used for Self when this metaphor is introduced is *atman*. As the teaching continues, Nachiketas is guided by Yama from a sense of the Self as a limited individual ego to knowledge of an eternal Presence, the divine Oneness that is omnipresent, omniscient and omnipotent. In the original, Sanskrit words such as *purusha* ('one that is abundant, that fills') and *svayambhuh* ('that which exists without cause') are used to convey this process. I have translated these variously as 'the Self', 'the ultimate Reality', 'the birthless One' and so on.

Regarding the sacrificial fire ceremony, we must understand it as more than a mere ritual. The ritual of sacrifice is an enactment of the interconnection of universal existence, in which nothing is for itself alone but exists because something else has offered itself up for its continued being, and because it in turn offers itself up for something else. This is true even at a cellular level: we 'burn' sugar in the presence of oxygen, which produces energy and carbon dioxide. The oxygen we breathe in is produced by vast rainforests, by the trees and plants throughout the world which, in

* *The Thirteen Principal Upanishads*, Robert Ernest Hume, Oxford India Paperbacks, Delhi, 1995

turn, breathe in the carbon dioxide we breathe out. Our failure to care for our environment is in part a loss of understanding of this kind of 'sacrificial' interconnectedness.

The number three crops up several times in the text, particularly in reference to the sacrificial fire ceremony. When Yama speaks of the sacrificial ritual, he is speaking of it as both a universal and a personal engagement. On the personal level, he is talking of a connection with 'the three'. Not named in this text, 'the three' could stand for father, mother and teacher; the knower, that which is known and the act of knowing; or the three kinds of activity, namely motiveless action, charity and self-discipline. I have opted for the latter translation as it introduces a set of values, the first step of any spiritual evolution.

In 'The Inner Terrain', Yama refers to those who 'know the five sacred fire rituals'. This is a theme that repeats itself throughout the Upanishads. The five fires are the knowledge by which we will know the true meaning of birth and death. They are the five stages in the descent and ascent of the soul: its original universal nature, which is sacrificed to become a vibration, which is in turn transformed into a material potential, which then converges with matter and which finally emerges from the womb into the world of the seen.

It is not possible to unearth every mystery in the text and it would be a mistake for any translator to try to do so. It really is up to the seekers, having gathered some background information, to delve into the text and allow its mysteries and teachings to find them and lead them on from wherever they are now.

Each Upanishad begins and ends with an invocation to set the student's mind to study. The invocation for the *Katha Upanishad* makes a fitting end to this introduction:

May we both –
The teacher and the taught –
Be protected by the revelation of knowledge.
May we both –
The teacher and the taught –
Be protected by safeguarding that knowledge.
Let us attain vitality together.
Let our study be inspiring.
Let there be harmony between us.
Om.
Peace. Peace. Peace.

The Beginning

The story goes that …

[1-2] *Vajashrava was engaged in a sacrificial ritual watched by his son,
Nachiketas. Through this rite the father hoped to achieve all that his
heart desired. But the son, watching the procession of gifts his father
was offering, became deeply troubled.*

[3] 'These cows', the boy said to himself,
'Will surely eat no more.
Nor will any of them yield another drop of milk ~
They are old and barren.
Yet my father presents them as gifts in a sacrifice.
What good can come of that?'

[4] Nachiketas, in the midst of the ritual,
Turned and interrupted his father asking,
'Father, to whom will you give me?'
There was silence.
Nachiketas repeated his question a second time.
Then a third.
Finally his father turned
And made the terrible pronouncement:
'To Death I give you, Nachiketas!'

[5] Nachiketas mused to himself,
'Among many I rank highly.

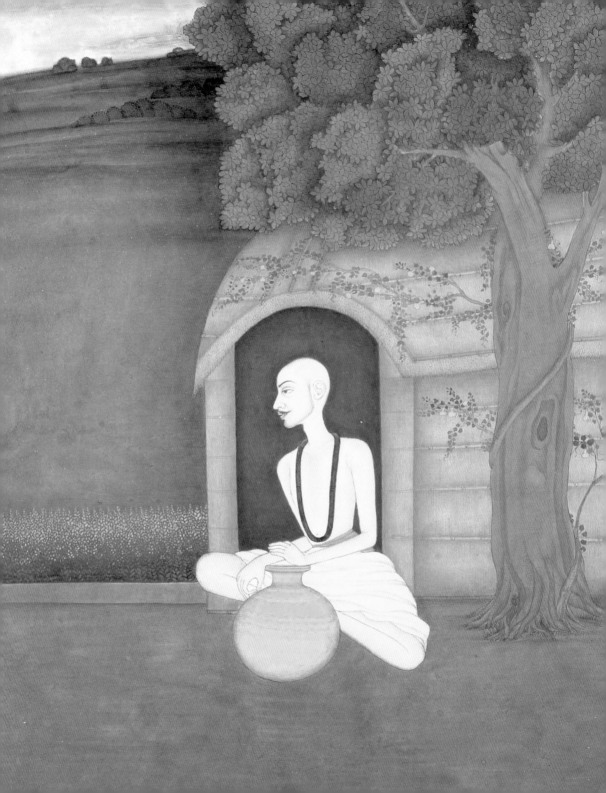

But among others I am merely average.
Yet, may my father today achieve his purpose
By offering me to Death.

6 'Things are now as they always have been
And always will be:
We humans wither like the corn of the field.
And yet, like grain cast on the ground,
We are born again.
To the realm of Yama, the God of Death,
I now go.'

7–8 *Yama, the God of Death, was away from his realm for three days and three nights, keeping Nachiketas waiting without food or water. A warning voice sounded in his ear: 'O Yama, be careful ~ a brahmin has entered your halls. You know that if you do not offer him all that an honoured guest should receive everything you have could be snatched away. These brahmins enter a house like fire ~ quick, offer him water.'*

9 Yama spoke,
'For three nights you have waited, honoured guest,
Let me now offer you my belated greetings.
And to ensure my continued well-being,

Ask any three wishes and I will grant them.
This is my promise.'

10 Nachiketas replied,
'This, then, is my first wish:
When I return to the world,
Embodied for me in my father,
Let all disharmony between us be gone.
Let me be recognized and welcomed.'

11 Yama easily agreed,
'Consider it done.
When you are seen again
By the eyes of the world that sent you here,
All hostilities will have ceased
And you will be known and embraced with joy.
And I add to the promise this:
The world will rest well with you
For many days and many nights.'

12 Then Nachiketas said,
'I understand that in heaven there is no fear.
That is because you are not there, O Yama.

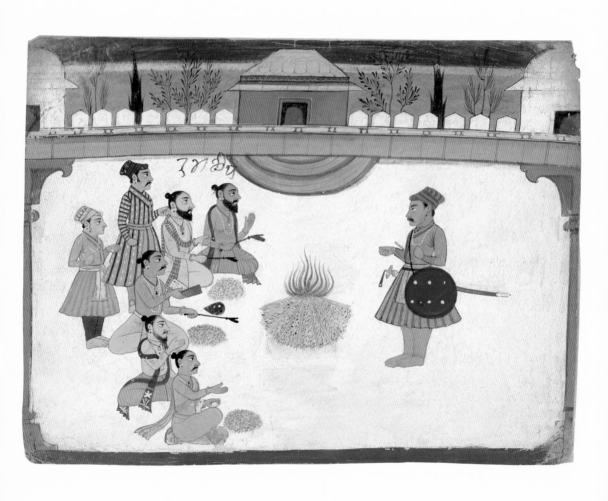

Nor are those other spectres, disease and old age.
Once in heaven, one has transcended both hunger and thirst
And crossed over the river of sorrows.

13 'At some time I may also wish to enjoy that heavenly world
And you, O Yama, know the means:
The sacred fire ritual.
I have faith in this fire and in you.
Teach it to me ~
This is my second wish.'

14 Yama agreed,
'Dear boy, that sacred fire which is the means
To heaven and is the support of all the worlds,
Actually burns deep within the hidden cave
Which is in the heart of each person.
Let me reveal it to you.
Look and listen well and you will learn.'

15 *Yama then revealed to the eager guest the essence and particulars*
of the sacrificial fire that first set in motion the creation of the worlds.
Nachiketas repeated with understanding everything that Yama taught.
Then Yama continued the teaching.

16 'You have a subtle mind and a noble heart,
Nachiketas, so to my promise I add this:
The sacrificial fire through which heaven is attained

Will now be named after you.
Henceforth people will speak of this sacred ritual
While uttering your name ~
Thus fame will be yours.
Accept from me this jewelled garland.

17 'From now on,
Anyone who studies, who knows and who lights
the Nachiketas Sacrificial Fire,
Who commits mind, reason and spirit
To lighting this sacred fire,
And who engages in the three sacred duties
Of motiveless action, charity and self-discipline,
Will go beyond birth and death
And attain knowledge of the great birthless One ~
The knowledge of which grants supreme Peace.

18 'Such a person, having lit the Nachiketas Sacrificial Fire,
Who is absorbed in the sacred three,
Will have cast off the bonds of death
And will rejoice in heaven.

19 'Knowledge of this sacred fire, O Nachiketas,
Was your second wish.
Now, state your third and final wish.'

[20] Nachiketas spoke,

'This is my third and final wish, O Yama.

There is much confusion about death:

Some say we continue to exist

After the body has died,

Others say we do not.

Tell me the truth ~

What happens when life leaves the body?'

[21] Yama responded swiftly,

'O Nachiketas, even the gods are confused about this.

It is an extremely complex matter

That will be difficult for you to understand.

Let me suggest that you choose something else.'

[22] Nachiketas replied,

'I am sure that even the gods have doubts.

And as you say, it cannot be easily understood.

But you, O Yama,

Are the supreme teacher on this matter.

So, really, I have no other wish.'

[23] Yama responded,

'Ask for sons and grandsons

That will live into healthy old age.

Ask for majestic elephants and swift horses,
Ask for gold and dominion over the earth.
You could even ask for a long life for yourself
Followed by a sojourn in heaven.

24 'Think of some other wish
Which has an equal value to you and ask that.
Wealth perhaps,
Or to become a mighty king.
I will make you fit
For any of these that you choose.

25 'You know these are things that are difficult to get.
Maybe you would like the company of beautiful women,
Many fine chariots and heavenly music.
But do not ask about life beyond life ~
It is something you will not understand.'

26 Nachiketas replied,
'But you understand.
These other things that you offer
Will all pass away ~
Keep them,
All of them.

27 'Wealth has never satisfied anyone for very long:
It cannot when we know we will die.

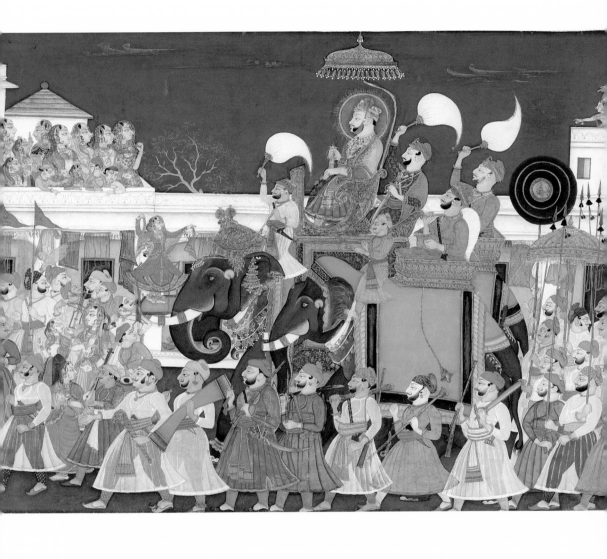

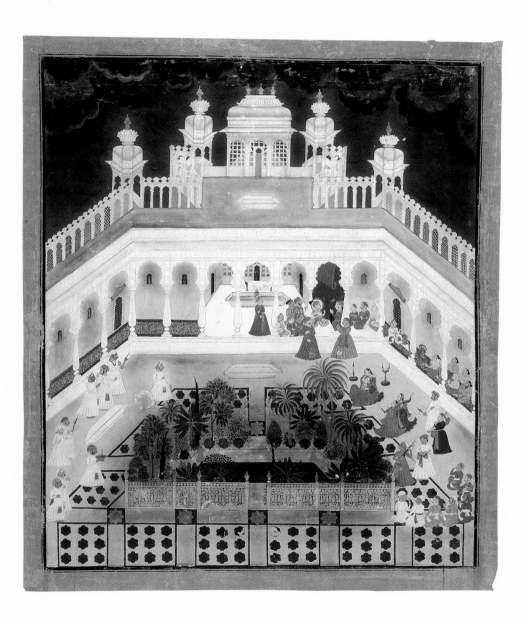

I may well live a long life
But one day I will have to die.
I have no other wish save the one already made.

28 'What mortal person in this world,
Confronted by their own mortality,
Can think about beauty and riches?
Even the longest life leads to death.

29 'You know all there is to know
About the great beyond.
O Yama, penetrate its mystery now
And reveal it to me.
I have no other questions and
I choose no other wish.'

The Secret Within

[1] Yama said,
'There are two paths, Nachiketas.
One path leads outward and the other inward.
You can walk the way outward that leads to pleasure
Or the way inward that leads to grace.
Of these two it is the path of grace,
Though concealed, that leads to the Self.

[2] 'Both of these paths lie before each person eternally.
It is the way of things.
Day by day, hour by hour, moment by moment,
The wise must distinguish one from the other ~
And then choose which to walk.
The foolish, grasping first at this and then that,
Choose to walk the path of pleasure.

[3] 'You, O Nachiketas,
Looked upon these objects of desire that I offered
And rejected them all.
In so doing you have chosen to walk the path of grace.

[4] 'These paths lead in opposite directions.
One leads to knowledge.
The other leads to ignorance.

You clearly desire knowledge, Nachiketas,
For you spurned the objects of pleasure.

5 'If you had chosen them
You would be like those who walk the other path ~
Revelling in their wit and limited learning
They do not even know the darkness of their own ignorance.
Round and round in circles they go,
Stumbling through disease, old age and death,
People of little vision being led
Along a bumpy path by the blind.

6 'The path of grace does not reveal itself
To one who blunders through this world
Totally committed to it and its limitations.
It is a subtle hidden path never revealed
To one who thinks that this world is all there is ~
And who, so thinking, falls again and again under my hand.

7 'Not many ever hear of the Self.
And of those that do, not many ever know It.
It is rare to find one who can teach of It.
And it is rare to find one who can learn of It.
Glory to both the teacher and the taught.

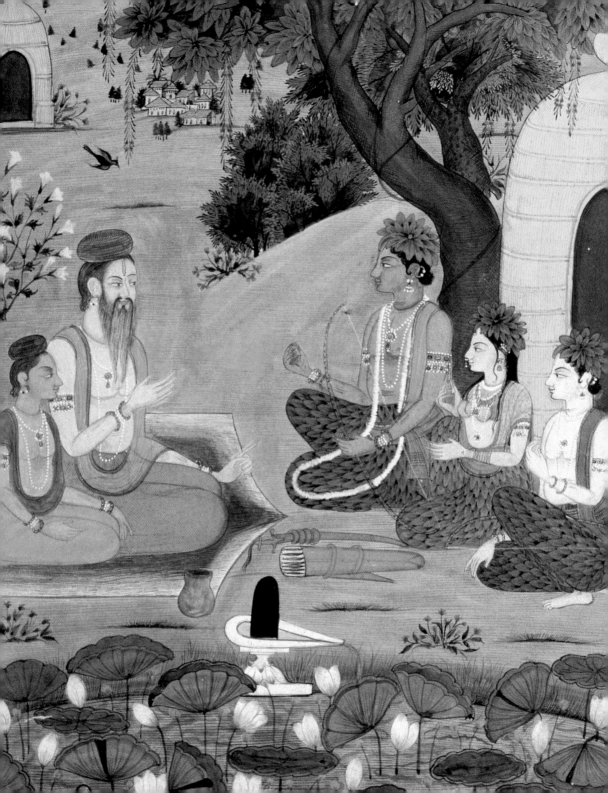

8 'This Self cannot be revealed by one who does not know It.
And one who does not know It wholly
Can only confuse by disclosing It in part.
But when taught by one who knows It truly,
It reveals Itself through the teacher.

9 'This Self cannot be reached by reasoning or debate ~
It must manifest Itself through a knowing teacher.
Your steadfast resolve, Nachiketas,
Has made a teacher of me.
May I always be approached by students like you.'

10 Nachiketas responded,
'I know that the treasures of this world,
Even when attained as a result of one's own actions,
Are transient things.
For this reason, I asked for instructions in the sacred fire
Which you named the Nachiketas Sacrificial Fire.
Now, into that fire which burns within
And which you revealed,
I offer all the rewards that I have accrued.
I do this to attain That which is eternal.'

11 Yama said,
'I know, Nachiketas.
I offered you every pleasure:
Fame, fortune and even a place in heaven,

And you rejected them all.
Draw near now and hear me.

12 'That Self which you wish to know,
Which is subtle and difficult to see,
Is there ~ deep within the deepest part of you.
Fix all your thinking and all your enquiry
On that ancient, radiant Self.
This practice is called *Adhyatma Yoga.*
Through it you will rise above both joy and sorrow.

13 'Having heard this truth
You must embrace it completely.
Continue separating the eternal from the ephemeral
And you will attain full realization of
That most inner, most exquisite Self ~
The source of true joy.
Nachiketas, you are ready for this experience.
Now walk that path of grace.'

14 Nachiketas asked,
'This Self which is beyond good and evil,
Beyond what is to be done
And what is prohibited from being done,

You know It.
Can you describe It to me?'

15 Yama answered,
'I will indicate It with a word.
It is a word that all the scriptures lead to
And all the self-disciplines
That are practised aim for.
That word is *Om*.
Through this word *Om*
The indescribable Self is symbolized.

16 'This single imperishable sound
Will lead you where you wish to go.
Whether you wish to know the Self
As it is embodied in flesh,
Or the Self as it transcends embodiment ~
Om will lead you there.

17 '*Om* is the unsurpassed means
For taking you from the glorious Self within
To knowledge of the Self beyond.
Contemplation of *Om* will lead you
Into that blissful realm of the ultimate Reality.

18 'That pure Consciousness
Which is the all-knowing, indwelling Self
Is neither born nor does It die.
It did not originate from anything
Nor has It ever become anything.
Unborn, undying, constant ~
It lives when this body dies.

19 'Those who think It can be destroyed
Or that It destroys ~
Neither of them knows.
For the Self does not destroy nor can It be destroyed.

20 'Smaller than the smallest particle of an atom,
And yet more vast than the whole expanse of space,
This Self resides in the heart of all beings.
Only those who have withdrawn their hopes from this world
Are open to the grace of that glorious Self ~
And only they see It.

21 'Unmoving, the Self moves.
Moving, It remains ever still.
How is It known ~
That which is beyond all joy and sorrow
And yet is embodied in both the joyful and the sorrowing?

22 'One who meditates on that Self
Which is formless in the midst of all forms,
Eternal in the midst of the momentary,
Which is everywhere at once and great beyond compare ~
Such a one will know that Self
And finally cease all grieving.

23 'That Self will not be found
Through much learning, thinking or listening.
What are the valid means of knowing It?
I will tell you:
It is known only through the Self within,
By the grace of That which the seeker seeks.
That Self alone reveals Itself in Its own glory.

24 'Who has not attained tranquillity or is corrupt,
Who has not turned away
From the brief satisfactions of this world
And attained stillness of mind,
Such a person cannot know the Self,
Though learned beyond compare.

25 'Ah! Who indeed can truly know that Self
Before which even the highest born are brought low ~
Before which death itself is reduced to nothing?'

The Inner Terrain

¹ Yama continued,
'In the heart of each person there are two desires:
The desire to know and partake of the world,
And the desire to know and be absorbed by the ultimate Reality.
Those who know this,
And who also know the five sacred fire rituals,
Speak of it as light and shade.

² 'The Nachiketas Sacrificial Fire Ritual and the sacred three
(Motiveless action, charity and self-discipline)
Can act as a bridge
For those who long for the ultimate Reality.
May we all master them.

³ 'Nachiketas, think of it like this ~
Imagine that the Self is seated in the back of a chariot.
The body is the chariot and awareness is the driver.
Think of the reins the driver is holding as the mind.

⁴ 'The senses are the horses that those reins lead to,
And the world and its many objects
Are the terrain the chariot moves along.
The Self, when it is in harmony with the body, mind and senses,
Is the enjoyer of the world and the doer of all actions.
So say the wise.

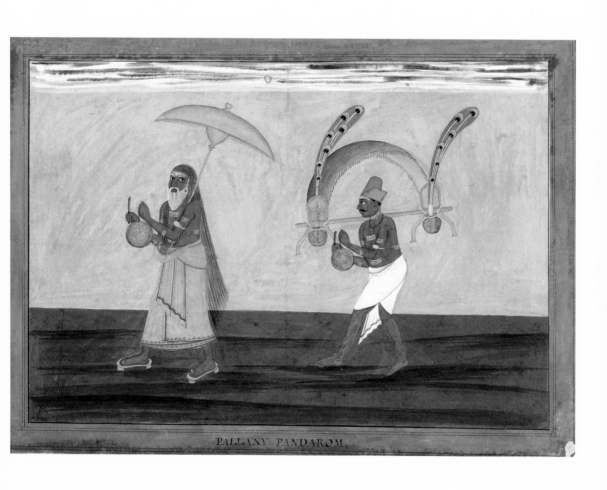

PALLANY PANDAROM.

5 'The foolish
Have minds that are scattered everywhere,
With senses that race after everything,
Like horses with the bit between their teeth.

6 'They are unlike the wise,
Whose awareness grasps the mind firmly,
Guiding the senses along the rocky pathway of the world
Like an alert charioteer.

7 'However, one who fails to remember
The presence of that radiant Self in the heart of the chariot,
Who becomes careless and corrupt,
Cannot reach the goal
That the Self directs the chariot towards.

8 'The driver who remains present to that Presence,
Who is mindful and true,
Will go beyond birth and death.

9 'Thus, with properly discriminating awareness as the driver,
A mind like steady reins directing the senses,
And a body that is steadfast,
One reaches That which provides
A dwelling place within Itself for all.

[10] 'More powerful than the senses
Are the desires that compel them,
More powerful than the desires
Is the mind that formulates them,
More powerful than the mind
Is the awareness which organizes it,
And more powerful than the awareness is the Self.

[11] 'Greater than the Embodied Self is the Transcendent Self.
Greater than the Transcendent Self is the Ultimate Reality ~
The Self, the ground of all things.
That is the goal.
That is the highest.

[12] 'Though present deep within all things
That ultimate Reality
Appears not to be there at all.
But it is seen by those
Who have eyes for the profound.

[13] 'The sincere seeker should inhibit speech
And let it be absorbed into the mind.
Then inhibit the activity of the mind
And let it be absorbed into the awareness.
Then let the awareness itself be offered to the Self ~

And let the Self absorb it.

Thus, finally, the Self will merge with the ultimate Reality.

14 'Arise! Awake!

You have had your three wishes ~ now use them.

But beware: even the wise poets say

This path is as narrow and sharp as a razor's edge.

15 'The only way to be delivered from the jaws of death

Is by seeking out That which is

Without taste, touch, sound or colour,

Which time cannot decay,

Which is beginningless and endless.

That which is ever present

Yet beyond reach of the awareness,

That from which even awareness is born.'

16 *The story of Nachiketas in which Yama gives this immortal teaching is a liberating tale. Whoever recounts it to others will have glory bestowed on them.*

17 *If one discloses its secrets to a gathering of those who are devout, or if one reverently recites it at rites for the dead, then such ceremonies will be blessed.*

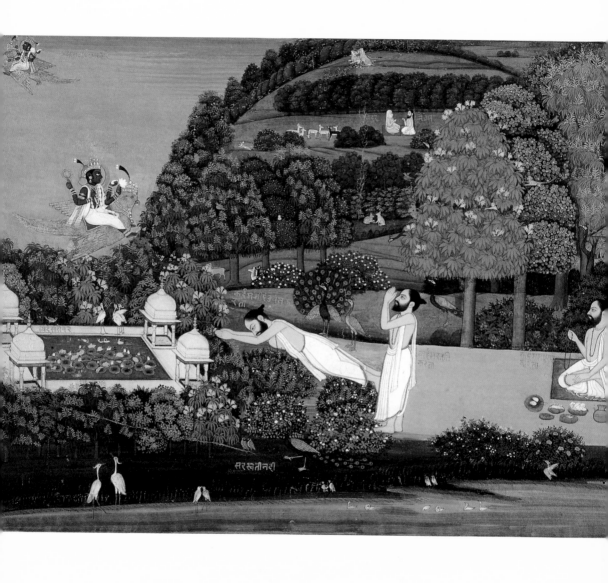

The Invisible within the Visible

[1] Yama continued,

'The Self of all makes the senses flow outward,
Therefore one seeks outside of oneself.
Only the wise,
Seeking the immortal amidst mortality,
Turn their gaze away from the world
And look inward ~
To find the Self.

[2] 'The foolish rush out into the world,
Reaching for all that they see,
Getting caught again and again
In the snares of death.
The wise cease looking for the real
In the direction of the unreal.

[3] 'For That, by which we
See all colours,
Taste all flavours,
Smell all fragrances,
Hear all sounds,
And feel the touch of our beloved,
That is the Self.

In truth, This is That which Nachiketas seeks.

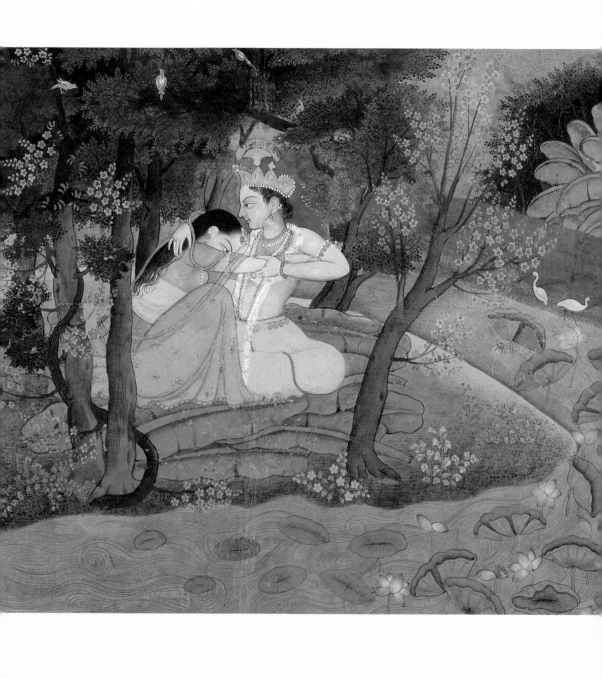

4 'Once the Self is known,
That Self which sees with eyes open or shut,
All sorrows end.

5 'This Self alone is the experiencer of all experiences,
It is the sustainer of all life,
And the ruler of time itself.
Who knows this Self
Rejects nothing and fears no-one.

In truth, This is That which Nachiketas seeks.

6 'This Self is the ultimate Reality:
That which was before creation
And from which creation was born.
Yet who sees this Self
Sees It resting in the hearts of all.

In truth, This is That which Nachiketas seeks.

7 'From this Self flows
Both the energy and the infinity
Which brought into being
The original creation.

This Self enters the hearts
Of all that are born of It.
Who sees this
Sees the Self,
Becomes the Self.

In truth, This is That which Nachiketas seeks.

8 'Look and you will see!
In the sticks being rubbed together
It is the hidden spark.
In the heart of each being
It is the fire that receives the oblation.
It is to each of us what the mother is
To her unborn child resting in the womb ~
Nourisher and protector.

In truth, This is That which Nachiketas seeks.

9 'That from which the sun rises
And into which it sets,
That which fixes the movements of the stars
And which transcends even the heavens.

In truth, This is That which Nachiketas seeks.

¹⁰ 'Whatever is present here ~
Is present there also.
Whatever is present there ~
Is present here also.
Who does not see this
Goes from death to death.

¹¹ 'Approach It with a mind
Sharpened by your practices,
And see the One in the many.
As long as you see diversity
You will go from death to death.
Cease this wandering
And embrace your oneness.

¹² 'The Self is there in the heart of everyone.
Smaller than the particle of an atom,
It is ruler of the past, present and future.
There is no turning away from That.

In truth, This is That which Nachiketas seeks.

¹³ 'This Self, smaller than the particle of an atom,
Is there in everyone ~
Like a flame without smoke.
Ruler of the past, the present and the future

It is That which was yesterday
And will be tomorrow.

In truth, This is That which Nachiketas seeks.

14 'Like rain on high ground
Which flows down into rocky ravines,
Who sees only diversity
Will run here, there and everywhere.

15 'Like pure water being poured into pure water,
Who sees only the One
Becomes the One.'

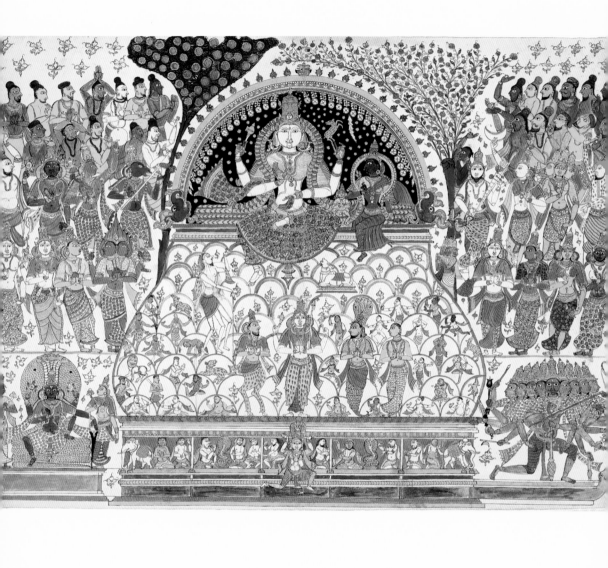

Knowledge beyond Sorrow

[1] Yama continued,
'That birthless One
Is the rightful owner of the body.
Contemplate this truth, grieve not and be free.

In truth, This is That which Nachiketas seeks.

[2] 'As the sun It lives in the heavens,
As the wind It moves through space.
Within the earth It is the molten fire.
At the altar It is the priest
And the libation.
It dwells among people
And It dwells among gods.
It is righteousness.
It is the unending infinity of space.
It is the essence of this earth and its waters.

[3] 'It is the Beloved seated in the heart of all beings
That directs the breath as it flows in and flows out.

[4] 'When this One that dwells within and without
Frees Itself and leaves the body ~
What then remains?

In truth, This is That which Nachiketas seeks.

5 'Mortals do not live because they breathe.
The source of all life
Is That which causes the breath to flow.

6 'Listen, and I will tell you
The secret of the Eternal and of the Self,
The secret of That which lives after death.

7 'It may enter a womb and be born again.
It may even become a motionless tree.
All will be in accord with the direction chosen
In the life that was lived:
Through the actions that were taken
And the truths that were heard.

8 'That Self, ever pure and radiant,
Continues creating all that delights us,
Even as we sleep and dream.
That Self is the immortal
And the transcendent ~
The ground of all beings.
There is no beyond beyond That.

9 'Just as fire is fire
No matter when or where it burns,
That One is all things
No matter what their form.

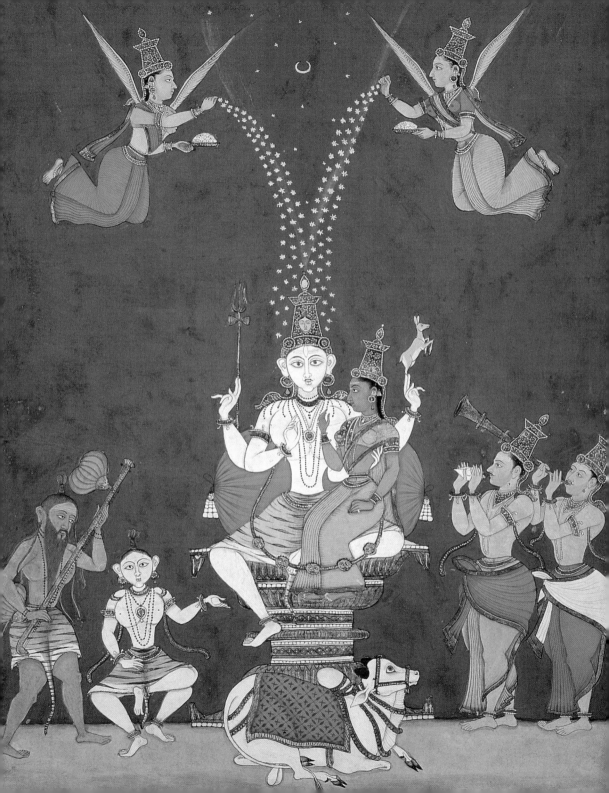

It is That which is within all,
And it is That which transcends all.

10 'Just as air takes on the shape
Of the vessel that contains It,
So the Self, the One, becomes the many.
Yet like the air, It remains forever free.

11 'Just as the sun
Sees the world by its own light
And yet remains free from its darkness,
So the Self,
The Inner Being of all beings,
Remains free from the sorrows
Of that in which It is embodied.

12 'There is only one Power ~
And it is That which is in the hearts of all.
Who knows this to be true
Gains eternal peace.

13 'It is the Self in the heart of all things
Which is the eternal amidst the ephemeral,

Consciousness within the conscious,
The giver of all bliss.
Who knows this to be true
Gains eternal peace.

14 'It is asked,
How is it possible to know this Self,
This Giver of Joy?
Will It be seen by Its own light?
Or will It be seen only as It is reflected in this world?

15 'I tell you now:
There, in that Self,
The sun cannot shine,
Nor the moon or stars.
The light of lightning cannot reach It,
Much less a conflagration on Earth.
Yet by Its presence all these are lit
And light shines forth.'

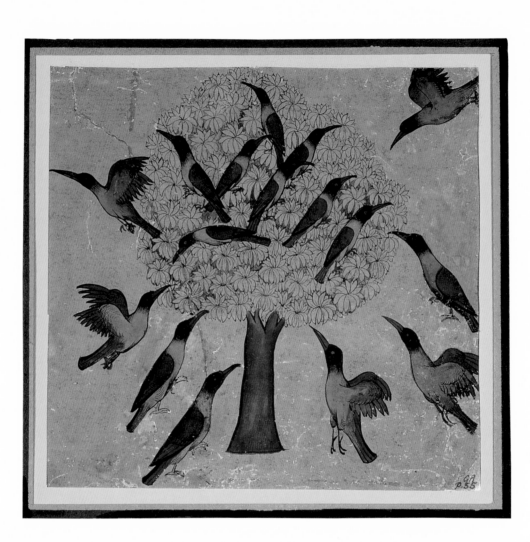

The Way Out of Birth and Death

¹ Yama continued,
'It is the eternal tree of creation
Reaching with Its roots up into the sky
And with Its branches down to the earth.
Its roots remain resplendent and immortal
And in Its branches the worlds come to rest.
There is nothing beyond That.

In truth, This is That which Nachiketas seeks.

² 'All of this creation and all that it contains
Emerged from this Self and moves within It.
Stand before It trembling
As if before a bolt of lightning.
Who knows this to be true
Gains immortality.

³ 'In reverence of That
Fire burns
And the sun shines.
In reverence of That
Even the mightiest among us move
As the wind moves.
Why, even death continues
In reverence of That.

4 'When you perceive That
While embodied here on Earth
Then you become eternally free.
Not perceiving That
You remain in the world of birth and death.

5 'A pure and quiet awareness
Sees the Self within
As clearly as it sees the body
Reflected in a mirror.
Those who dwell close to the Self
See the Self as clear as light.
Those who have already passed into death
See It as if in a dream.
Celestial beings can see It only
As a reflection is seen on moving waters.

6 'The senses of the body ebb and flow ~
That is their nature.
Knowing this,
The wise do not lament for that which passes away.

7 'Remember,
Greater than the senses is the mind
And greater than the mind is the awareness.
Greater than the awareness is the embodied Self,
And beyond that, the transcendent Self of all.

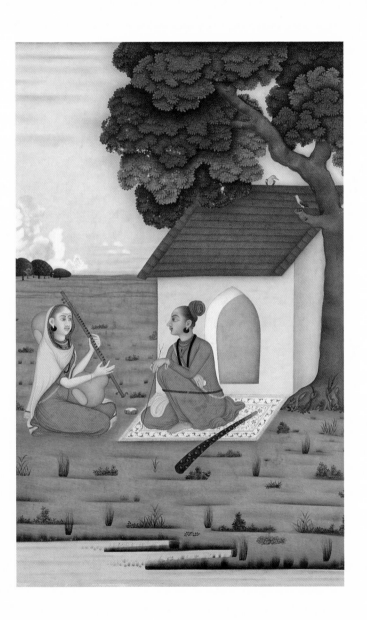

8 'That is the ultimate Reality
That must be attained while embodied.
It is That which will make you free.

9 'It is not in the ordinary field of vision,
Nor is it seen with the eye.
But when the mind is stilled
And the awareness focused
The Self within the heart will reveal
Its transcendent nature,
And It will make you free.

10 'Let the five senses
And the mind they serve become still.
Let awareness itself
Cease all activity and become watchful.
Then you will have begun your journey
On the highest path.

11 'This is Yoga.
But beware: remain ever vigilant,
For even this state of Yoga can ebb and flow.

12 'Remember always ~
Not with my speech,

Not with my eyes,
Nor even with my mind
Will that Self be reached.
It will declare Itself to me
Only in my stillness.

13 'Remain present only to that Presence,
Knowing that It is what is.
Then It will reveal Itself
In Its essence and in all Its glory.

14 'When your heart is free
Of all the desires that now surround it,
You will stand at the gates of immortality
Before that Self.

15 'While living, cut all the ties that bind
Your presence to this world,
And enter into that Presence.
This alone is the teaching
Of the sacred scriptures.

16 'One hundred and one rivers
Flow from the heart in all directions.
Only one ~ the shining way ~

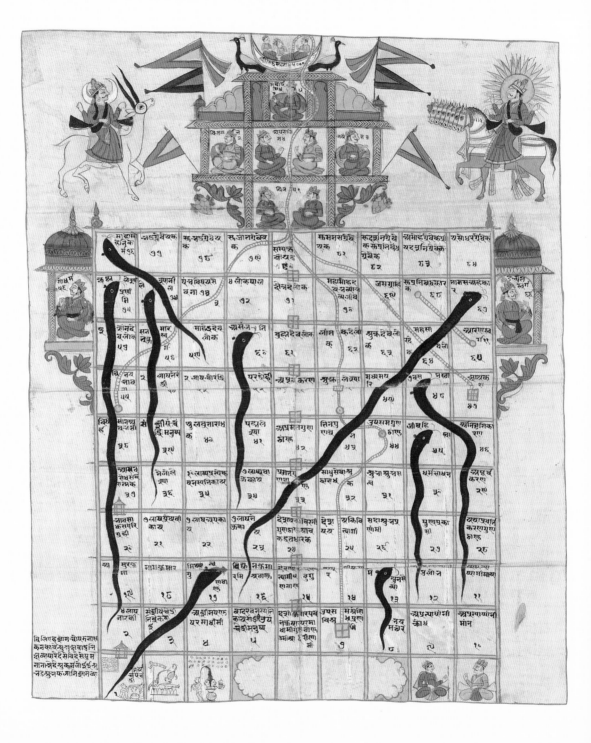

Will take you upward beyond yourself
To that Self of all
And the realization of immortality.

[17] 'That Inner Being is there
Present in the hearts of all.
Bring all that you are before That:
Draw It out as you would
A shaft from the centre of a reed.
Know this pure and immortal Truth.
Indeed, know this pure and immortal Truth.'

[18] *What then happened to Nachiketas? Nachiketas came to the realm of
death free from vice and virtue, and free also from desire and ignorance.
This teaching given by Yama took Nachiketas through the final Yoga to
merge with the Self. Not only Nachiketas, but all those who choose the
path that Nachiketas chose, attain the Self.*

Indian Miniature Painting

Painting in India is an art of great antiquity although because of the perishable materials used, such as palm leaf, no paintings other than wall-paintings have survived that are earlier than about 1000 CE. After this date, many examples have been preserved of a flourishing tradition of Hindu, Jain and Buddhist manuscript illustration. Emerging out of this tradition, a great new flowering of the art of miniature painting began around the early sixteenth century, and the paintings illustrated in this book reflect something of the diversity of styles that subsequently developed.

The environment for which these miniatures were produced was predominantly courtly, and individual rulers had considerable influence over the style and subject matter of the paintings that were made for them. The identity of the artists is, by contrast, often totally obscure, and comparatively few names and fewer facts about the lives of most of the artists are known, although certain influential artists have been identified.

The earliest surviving miniatures are illustrations for religious manuscripts, and this tradition remained important throughout the history of miniature painting. Depictions of Hindu deities were a popular theme (front jacket, pages 44, 47), as were illustrations from classical texts with their tales of gods, heroes, lovers, sages and quiet forest hermitages – a world familiar to the composers of the Upanishads. Artists were able to draw on a great treasury of episodes from literary works that had come into being during the last millennium BCE, many of them originally oral compositions that were only later written down. Among the most popular texts for illustration were the great epics, the *Mahabharata* and the *Ramayana*. The *Mahabharata* tells the story of the struggle of the Pandava brothers to regain their kingdom from their enemies, the Kauravas (page 16). The *Ramayana* is the story of the hero Rama, an incarnation of the god Vishnu. It describes his long years of exile in the forest with his wife Sita and brother Lakshmana (page 26), and his eventual defeat of the terrible demon Ravana. Into the main plots of the two epics are woven many other stories. Those that feature in the *Mahabharata* include the tale of the love of Nala and Damayanti (title page) and legends of the sage Kardama (page 37), who was praised by Vishnu for his thousand-year-long religious austerities. The ancient epics, their heroes and heroines, and their profound philosophical discussions, such as the renowned *Bhagavad Gita*, remain extremely important in Hinduism today. Artists could also draw on secular works such as the *Panchatantra*

(page 50), a treatise on government told through a series of animal fables, probably dating to around 300 CE.

By about the fifteenth century, Hinduism was experiencing a renaissance with the rise of the *bhakti* cults of devotion to deities such as Krishna, which were highly influential in the development of literature and painting. Stories and poems about the life of the god Krishna were to become extremely popular as subjects for illustration, and painters delighted above all in the stories of his mischievous childhood and youth, and his love for the young herdswoman Radha (page 39). Their love was seen as an allegory for the devotion of the individual soul to the deity, and thus suggests the desire of the individual soul for unity with the eternal. The archetypal heroes and heroines of the elaborate treatises and poems on love were, from the seventeenth century, sometimes depicted as Radha and Krishna, blurring the distinction between the religious and the secular.

The influence of the Mughal school of painting, which developed under the Muslim Mughal emperors in the late sixteenth and seventeenth centuries and fused many Iranian and even European elements with Indian traditions, gradually introduced more secular subjects to the regional Hindu courts. Portraiture and scenes of courtly life appeared, such as the relatively large paintings of processions and festivals from Udaipur and Kotah in Rajasthan, which often glorified the ruler in his royal magnificence (pages 21, 22). The Mughal interest in scenes of daily life, visible here in the late Mughal art of Murshidabad (pages 13, 53), extended to depictions of Hindu holy men and hermits, whose way of life reflected that of those who composed the Upanishads over two thousand years before. This interest in recording scenes of Indian life was taken further by European collectors and patrons, who began to influence some schools of Indian painting from around the late eighteenth century. They created a considerable demand for depictions of local people and customs (page 33).

Stylistically, a bold and dynamic use of colour and a preference for a strong, flat composition, with little attempt to create an illusion of three-dimensional space, were characteristic of the early miniatures of the sixteenth-century Hindu courts. Mughal art introduced a more naturalistic approach and a sense of spatial depth, visible here in its late manifestations from Murshidabad.

Rajput painting, the courtly art made for the Hindu 'sons of kings' of Rajasthan and the Panjab Hills, with their proud heroic and chivalrous traditions, had its roots in the rich, vibrant, early tradition. However, the regional Rajput courts each absorbed Mughal influences in varying ways and to different degrees, and this partly accounts for the remarkable diversity of these regional schools. A broad distinction is drawn between the art of Rajasthan and Central India and the 'Pahari' painting of the Panjab Hills, a region of small kingdoms in the Himalayan foothills. Within each category were many flourishing and distinctive local schools, such as the lovely, lyrical style that developed in Kangra in the late eighteenth century (pages 26, 39). Artistic conventions, such as the depiction within a single scene of figures at more than one point in time (page 37), were used in some schools and would have been readily understood. Following the decline of central Mughal power, Mughal painting also diversified into local styles such as that of Murshidabad, with its austere and cool palette. Eventually, due to the influence of European patronage, the hybrid 'Company' style emerged (page 33). This fused Indian and European artistic traditions – a new phase in Indian art had begun.

Nick Barnard
Indian and South-East Asian Department
The Victoria and Albert Museum

Captions to the Illustrations

Cover: D.379-1889. *The sun god Surya in his chariot.* Bundi, Rajasthan, *c.* 1770. Gouache with gold on paper. 16.2 x 25.4cm.

Title page: IS.32-1954. *The swan that tells Damayanti of Nala's beauty* (detail), painting from a *Nala-Damayanti* series. Bilaspur, Panjab Hills, *c.* 1760–70. Gouache with gold on paper. 16.2 x 25.4cm.

Page 13: D.1191-1903. *An ascetic with a water pot outside his hut.* Murshidabad, Bengal, *c.* 1760. Gouache on paper. 21.1 x 13.6cm.

Page 16: IS.1-1970. *A sacred fire ritual.* The king (on the right), for whom the priests are performing the ritual, is probably Yudhishthira, King of the Pandavas, at his capital Indraprastha in a scene from the Mahabharata. Bilaspur, Panjab Hills, *c.* 1670–80. Gouache on paper. 22.9 x 30.7cm

Page 21: IS.564-1952. *Maharao Ram Singh II of Kotah riding in procession with his son Chhattar Sal, who rides the smaller elephant.* Kotah, Rajasthan, *c.* 1850. Gouache with gold on paper. 32.5 x 48.9cm.

Page 22: IS.77-1990. *An evening entertainment in the City Palace.* Maharana Raj Singh II of Mewar, shown with a halo, surrounded by dancers, musicians and courtiers. Udaipur, Rajasthan, *c.* 1755. Gouache with gold on paper. 55.7 x 50.2cm.

Page 26: IM.82-1912. *Rama, Sita and Lakshmana at the hermitage.* Illustration to a *Ramayana* series. Kangra, Panjab Hills, *c.* 1830. Gouache with gold on paper. 21.3 x 14.5cm.

Page 33: AL.9128:9. *A holy man and a pilgrim on their way to the famous temple of the god Subrahmanya at Palani.* Both men beat gongs, while the pilgrim behind carries a portable seat with an awning, water pots and peacock-feather fans. Part of an album of thirty-six paintings of the people and occupations of South India. Tanjore, Tamil Nadu, *c.* 1770. Gouache with gold on paper. 23.1 x 32cm

Page 37: IS.255-1952. *The great sage Kardama prostrating himself before the god Vishnu.* The god has come on his vehicle, the eagle Garuda, to praise Kardama at his hermitage for the religious austerities he has been practising for ten thousand years. Both Kardama and Vishnu are shown at more than one point in time. Rajasthan (probably Jaipur), *c.* 1800. Gouache with gold paper. 23.3 x 34.8cm.

Page 39: IS.15-1949. *Radha and Krishna in the grove.* Kangra, Panjab Hills, *c.* 1780. Gouache with gold on paper. 13.3 x 17.6cm.

Page 44: AL.1756. *Representation of the god Shiva and his consort Parvati seated as if on a Himalayan peak.* They are being worshipped by sages and deities. Southern India, *c.* 1800. Brush drawing with colour wash on paper. 54.6 x 76.7cm.

Page 47: IS.208-1953. *Shiva and Parvati enthroned.* Celestial beings and musicians entertain them and sprinkle them with flowers. Shiva's vehicle, the bull Nandi, sits before them. Eastern Deccan (perhaps Masulipatam), *c.* 1780. Gouache with gold on paper. 22.3 x 17cm.

Page 50: IS.247-1952. *Tree with crows.* An illustration to a story from the *Panchatantra*, a treatise on government told through a series of animal fables. Bundi, Rajasthan, *c.* 1850. Gouache on paper. 15.8 x 16.4cm.

Page 53: D.1170-1903. *Two female ascetics, one playing a vina.* Murshidabad, Bengal, *c.* 1750–55. Gouache with gold on paper. 21 x 13.3cm.

Page 56: Circ.324-1972. *Board for the game of knowledge, the precursor of snakes and ladders.* The aim of the game, played with dice, is to ascend towards the highest states and avoid the hells at the bottom. The ladders represent good conduct and knowledge while the snakes stand for evil and ignorance. This example is a Jain version of the Indian game, which was popular in northern and western India in the 18th and 19th centuries, but probably has earlier origins. Rajasthan, 19th century. Gouache on cloth. 58.4 x 52.4cm.

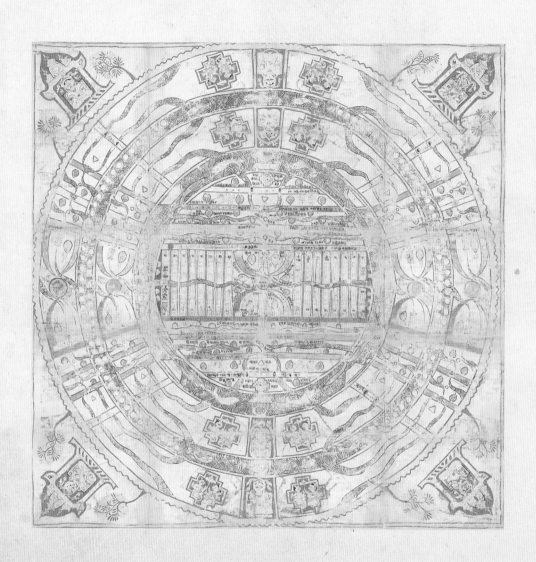